IMAGES
of America

AROUND
CLEARWATER

ON THE COVER: Icons from early days, this steamboat and its wanigan cruised the Mississippi, transporting supplies and people to various locations. Joel Bean Bassett, who owned the J.B. Bassett Lumber Company, designed and built the *J.B. Bassett* in 1894. This paddle-wheeled operation followed log drives from St. Cloud to Anoka, stopping in Clearwater coming and going. Children ran to the riverbanks to get freshly baked cookies from the cooks. (Courtesy of the Frank-Stupnik families.)

IMAGES
of America

AROUND
CLEARWATER

Cynthia Frank-Stupnik

ARCADIA
PUBLISHING

Published by Arcadia Publishing
Charleston, South Carolina

Printed in the United States of America

Library of Congress Control Number: 2015958296

For all general information, please contact Arcadia Publishing:
Telephone 843-853-2070
Fax 843-853-0044
E-mail sales@arcadiapublishing.com
For customer service and orders:
Toll-Free 1-888-313-2665

Visit us on the Internet at www.arcadiapublishing.com

I dedicate Around Clearwater *to my parents, Harold and Winnie Frank, who took an active role in their community and taught my siblings and me the value of home, church, and the love of history. I also learned that sometimes, to find historical truth, one must work harder, dig deeper, and erase lies. (Courtesy of the Frank-Stupnik families.)*

CONTENTS

ACKNOWLEDGMENTS

I love history. Wherever I travel, I look for the hidden, the reason a city or landmark is important. I developed this interest from my parents, who were interested in their heritage and the world around them. Clearwater, home, has inspired me the most. Individuals like Jennie Phillips, Maud Porter, and Jeannette Sanborn Whittemore symbolize what women can do, have done, and will by their strength of nature continue to do.

This is an image-inspired book. If I did not have access to an image, picture, or advertisement, I couldn't write the story.

I could not have accomplished this undertaking without help from Becky Frank. By writing this book, I believe I have learned even more about Clearwater. When I gathered materials, I thought I knew a lot, yet as I researched more, I saw connections between people, places, and events that had not been there for me before. Clearwater is truly a historic landmark.

I also want to thank others who helped me gather and learn along the way: Elaine Paumen for pictures and endless phone calls for historic information; Nancy Moll and her sister Sue Lynn Doering for providing some of the most unique pictures of her families; Carol Freeman and Sally Flynn for donating some of the pictures at the Church of St. Luke's in Clearwater; Kitty Johansen for the pictures of Boutwells and Maud Porter. A thank-you goes to Margaret Heinks for searching the Clearwater United Methodist Church for images. I cannot forget Larry and Joan Krenz for providing information about the Hollywood Motel and Café.

I want to acknowledge the John R. Borchert Map Library at the University of Minnesota, *History of Wright County, Minnesota* by Franklyn Curtiss-Wedge, and Volumes I and II of William Bell Mitchell's *History of Stearns County Minnesota*. Without these aids, my research would have been harder and taken more time.

I also want to give a special thank-you to Henry Clougherty, my title manager, for his guidance while I was doing this project.

Unless otherwise noted, all images, ephemera, and research should be credited to the Frank-Stupnik families.

INTRODUCTION

It is hard to imagine Minnesota without the Vikings, the Twins, or the Mall of America. Yet until the early 19th century, this stretch of territory lay fallow except for what was used by native peoples and fur traders. Lakes, rivers, creeks, bluffs, virgin prairie, and a vast forest called the Big Woods covered much of the area. Many early explorers rejected the idea that the country was suitable for growing anything sustainable because of its harsh winters. Not until the 1820s did a soldier at Fort Snelling, a Lieutenant Camp, plow up land, plant seed, and sow vegetables, proving that, indeed, the land could provide sustenance. Once what would eventually become Minnesota was opened for settlement in the late 1840s, the pioneer movement began. Europeans came looking for land to farm and raise families, inhabiting the southern part of the country. Immigrants from the eastern part of the United States and Canada looked for fertile soil and the opportunity to increase their means by logging. When some of the settlers saw the open parcels around the Clearwater and Mississippi Rivers, they envisioned infinite opportunities for those wanting to start a new life.

It did not take long for these men to realize that they had some of the richest and most fertile land in Wright and Stearns Counties, with prospects of making good. Located on the west side of the Mississippi, the Clearwater area offered early settlers rich bottomland, meadows, and prairies waiting for livestock and cultivation. They knew that the land was ripe for planting. The War Department's early studies, Minneapolis founder John Harrington Stevens's chronicles, and Clearwater founder (and brother to John) Simon Stevens's 1850 and 1851 experimentations in farming near St. Anthony Falls had proven this. Simon Stevens successfully planted and harvested onions, cabbages, beans, peas, squash, pumpkins, and potatoes. After setting his eyes on the land in Clearwater, Simon Stevens knew that he was not that far north of the falls, so the crops had a good chance of survival. He also figured that wheat, corn, and oats could be solid cash crops as well as feed for livestock such as cattle, horses, pigs, and chickens. He and other early pioneers began to plat out the townsite and choose acreage for themselves and those they knew would follow them to build up this new community.

Waterpower enlarged these early village founders' visions for shipping as well as their ever-prosperous hopes of everything logging-centered. After the territory opened east of the Mississippi for settlement and logging, the quest for the infamous white pine seized a life of its own. The Big Woods covered much of the south-central territory. Even though the area that the pioneers planned on settling was a bit north of what some considered the border of this vast ecosystem, it contained some of the finest accumulations of timber, including sugar maple, oak, and elm, under a canopy of white birch. And with both rivers nestling near their town boundaries, the men were sure to acquire enough settlers who matched their hopes and dreams to build a community around them to become a success. The shores of the Clearwater River could provide the platform for mills. Simon Stevens had previous logging experience. In the 1850s, he cleared trees by St. Anthony in order to plant his garden and in the woods by the Rum River for logging. In addition, he and

Calvin Tuttle had explored land southwest of St. Anthony and found a large body of water that was eventually named Lake Minnetonka. They filed claims and built a sawmill, which the two operated until 1854. With Stevens's know-how, he and friend Horace Webster, who also laid a claim at Minnetonka, could settle in and develop a village on the eastern bank of the Clearwater River. From there, the Mississippi could provide the passage for their goods to southern markets.

Maybe the early settlers were not romantics, but they envisioned building homes and re-creating what they had left behind to venture into a new territory, and they did just that. Because many in the village came from the East, they constructed their houses, churches, and businesses to resemble those they left behind in New England. Clearwater had charm. It lay burrowed below the bluffs overlooking the two rivers. The arch-like trees sheltered the streets, providing a quaint and tranquil atmosphere for the early settlement. At one point, it had five dry goods and grocery stores, one drugstore, one furniture store, two cabinet shops, one shoe shop, three blacksmith shops, one millinery store, one steam sawmill, one water-run sawmill, two flour mills, one wagon factory, one harness shop, two jewelry shops, two hotels, one attorney, and at least three doctors. Yet, once the town became more populated, it also focused its attention on religion, education, and other social pursuits. A school was built on top of the hill but was then sold to the Catholics to be used as a church. A new school was built on Bluff Street, overlooking the Mississippi, and was later remodeled and added onto to house a high school. Since religion was a foundation for their lives, the Methodists built a church on Main Street, and the Congregationalists built theirs on Bluff. Both white edifices still stand as emblems of the strength and determination it took to build a village.

The Clearwater area has had a long history of boom and bust. In the beginning, excitement spread, and others pioneers followed those who came first. But a number of decisions and a few setbacks, like the Sioux Uprising, the rise and fall of the American dollar, and plagues of grasshoppers and infectious diseases, affected the population at different times and for different reasons. From river to railroad and now to freeway, the village has evolved, but over the 160-plus years of settlement, the scenery remains much the same as when it was first settled in the early 1850s.

One

EARLY NAVIGATORS

A welcoming site of rolling bluffs overlooking the Mississippi, rich, virgin prairie, and thick timberland greeted the first settlers who searched for land to claim. The first permanent settler was Selah Markham, from Genesee, New York. He arrived around 1854, soon after settling with his wife and five children on what they called Big Bend.

Alonzo Boynton, from Maine, and Asa White, from Pennsylvania, soon followed, staking their claim to what they called El Dorado, while John Oakes and his family came from Maine in 1855.

Thomas Porter arrived in Minnesota around 1848 and traded with the Indians from his half brother's mercantile store in St. Louis, Missouri. In 1853, he staked a claim east of the Mississippi, later preempting one that he lived on in the village for the rest of his life. Porter wore many hats, most importantly serving as a state representative for three terms.

Simon Stevens, Horace Webster, and John Farwell from Canada arrived in the area in 1855. They took up claims and formed a town company, only to find the area had already been claimed by White and Boynton. After a tussle, Stevens, Webster, and Farwell bought out the original townsite, renaming the village Clear Water, eventually spelled Clearwater.

Nestled on the boundary line of Wright and Stearns Counties, the town and township spread north, south, and west. Simon Stevens, from Quebec, was born in 1827. He joined older brother John Harrington Stevens, founder of Minneapolis, in Minnesota Territory. After he helped plat out the new village, Simon became a farmer, stockman, hotelkeeper, ferryman, blacksmith, and postmaster. Horace Webster, who claimed land in Clearwater Township, began with 160 acres of untamed land and a small log cabin and developed it into 225 acres with a frame house and outbuildings.

A veteran of the War of 1812, Luther Laughton along with his family joined others at Big Bend, Minnesota, in 1855, arriving from Brighton, Maine. Luther and sons Josiah, Orrin, and Nathan farmed in Clearwater Township. Later, Luther Laughton II, son of Nathan and grandson to the elder Luther, owned a meat market in the village.

The courage and vision of these early settlers, and their pioneering spirits, would go on to define the residents of Clearwater for generations after. These qualities, woven into the fabric of Clearwater and its residents, are an inspiration to look back upon and are ever-present today.

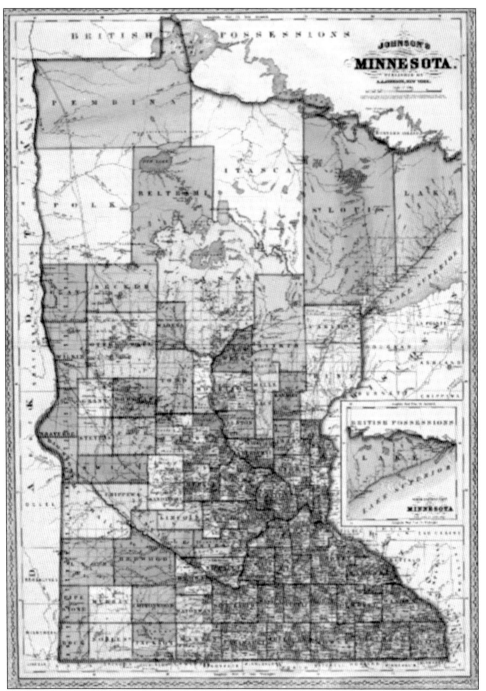

Situated in what would become the state of Minnesota in 1858, Clearwater, located at the very tip of Wright County, is bordered by Stearns and Sherburne Counties. Here, the Clearwater River flows into the Mississippi. Early studies done by the War Department and the Stevens brothers proved that the land could sustain a variety of crops and livestock and offered the finest accumulations of timber, including sugar maple, oak, and elm. (Courtesy of the John R. Borchert Map Library at the University of Minnesota.)

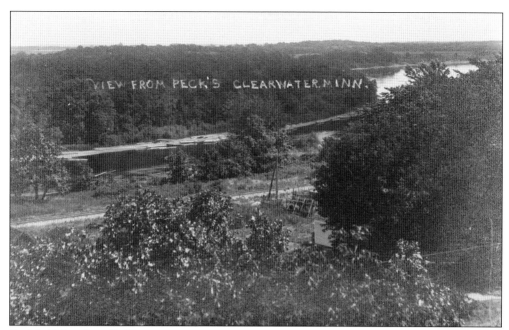

Entitled *View from Peck's, Clearwater, Minnesota,* this picture was taken from the top of the bluff. William Peck was the son-in-law of John Harrington Stevens, founder of Minneapolis. This photograph was taken from outside his house overlooking the river. When the first settlers arrived in Clearwater, they were greeted by the site of rich prairie, thick woodlands, and, of course, the Mississippi River.

Selah Markham was the first to settle in the area in 1854. Born in New York, he moved to Illinois when he was 25. He and his family traveled to Minnesota Territory, where they homesteaded in Clearwater Township, four miles south of what would become Clearwater. Markham was a wagonmaker, blacksmith, and farmer. He helped build up Wright County, becoming the first commissioner and assessor.

The first settlers arrived in 1854 and settled on a curve on the west side of the Mississippi River that they called Big Bend. Located a few miles from the future Clearwater, this precinct fulfilled its county obligation to build and maintain a school. The first teacher was Ellen Kent. In 1855, the census taker counted 62 men and women residing in the area, each supporting education.

Shoemaker, trader, lumberman, farmer, Wright County commissioner, and state representative, Thomas Porter wore many hats. He was also a Clearwater assessor, treasurer, and Royal Arch Mason. Born in Norristown, Pennsylvania, in 1826, he married Abigail Perkins Robinson Camp, another early settler. The couple had two children, a son, Tarrant R. (1857–1860), and a daughter, Jessie Maud Porter, one of the first white females born in Wright County. Thomas died in 1903.

Many area journalists paid tribute to Simon Stevens when he died because he did so much for Minnesota. One of the first settlers in Clearwater, he was born in 1827 to Gardner and Deborah Harrington Stevens in Quebec. The youngest of 10 children and brother to Minneapolis founder John Harrington Stevens, Simon pioneered in Hennepin County, building a dam on Lake Minnetonka before journeying north, where he joined others to plat out Clearwater. He died in 1904.

Simon Stevens built this log house on his claim just south of the village. Stevens became a successful stockman and farmer. He held an active interest in the village, holding a number of positions, such as postmaster and overseer of the poor. He married Katherine Cole. Son Henry helped maintain the farm and became a ranchman in South Dakota. Charles became a teacher and minister.

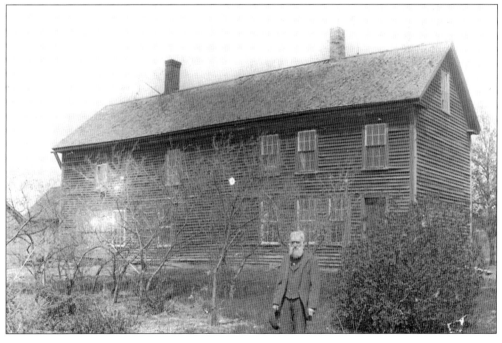

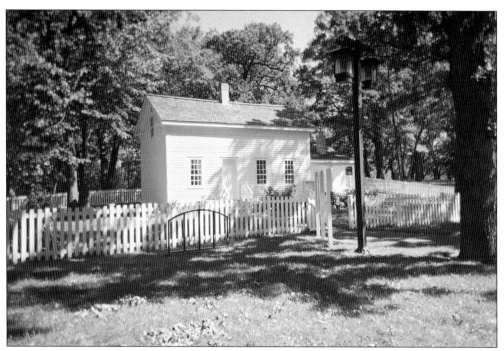

Brother to Simon Stevens, one of the owners of Clearwater, John Harrington Stevens was the first to settle on the west side of the Mississippi River. Located on the west side of St. Anthony Falls, his clapboard home was the site of many legislative, educational, and agricultural meetings. A peaceful man, he sought ways to keep the Dakota Indians, who often camped around his house, pacified while still trying to open more land for settlement. In this home, the name of the future city of Minneapolis was claimed. He served in the legislature four times, was a promoter of first the territory and later the state of Minnesota, founded Minneapolis and Glencoe, and was president of the state agricultural society. His house was moved twice and now resides in Minnehaha Falls.

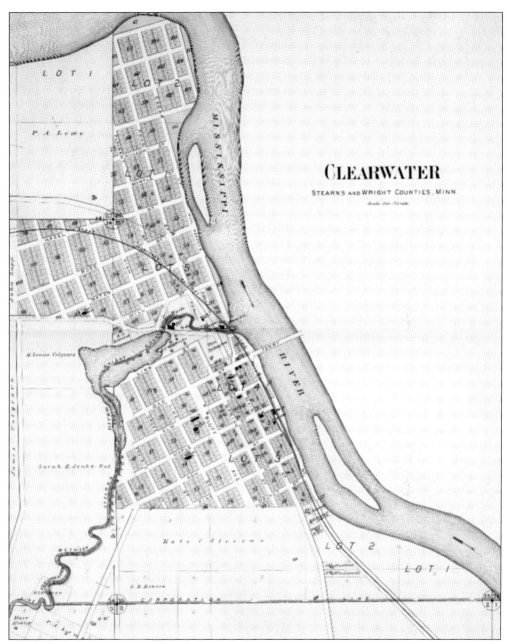

Nestled on the boundary line of Wright and Stearns Counties, the new village of Clearwater had a dispirited start. Simon Stevens, Horace Webster, and John Farwell arrived in 1855, took up claims, and formed a town company, only to find the area had already been claimed by earlier pioneers Asa White and Alonzo Boynton, who called the village El Dorado. After a heated discussion, Stevens, Webster, and Farwell bought out the original townsite, renaming it Clear Water. They platted out the village, envisioning the creation of homes and businesses. This 1896 map illustrates the flow of the rivers as well as the blocks, avenues, streets, buildings, and land ownership.

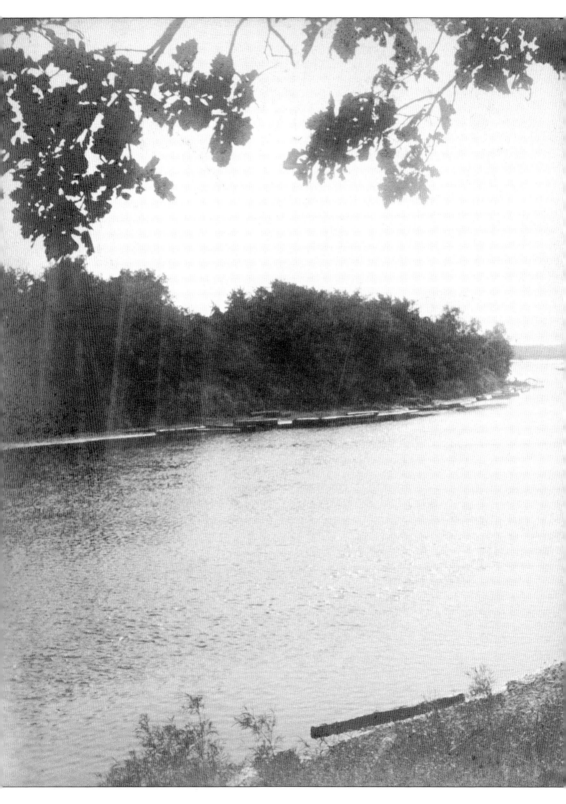

One of the longest rivers in the world and often referred to as the "Father of Waters," the Mississippi River winds its way from its headwaters at Lake Itasca to the Gulf of Mexico. At Clearwater, the river, surrounded by the natural beauty of bluffs and flatland, caught the eye of many early settlers. With many tributaries—including the closest, the Clearwater River—the land looked fertile for growing crops, offered fish and wildlife for sustenance, and provided a waterway to markets. Steamboats brought settlers, visitors, and loggers to the village to help with the busy lumber industry. Mark Twain probably never traveled up this part of the tranquil Upper Mississippi River. If he had, he might have romanticized about the river's beauty as it meanders slowly southward. On the other hand, he might have embellished a few stories about rough and tough steamboat cooks offering sugar cookies to town children watching the logging activity from the riverbanks, or Thomas Porter ferrying some women across the river to the Sherburne County side to get married.

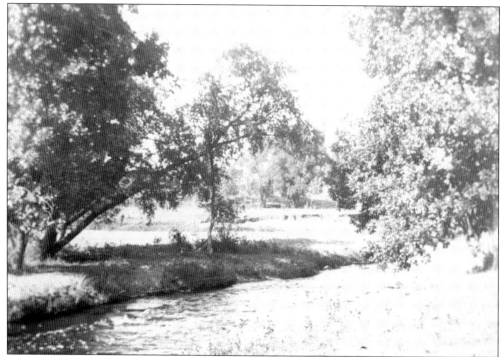

Here, where the Clearwater River begins to merge with the Mississippi, early settlers would make their plans to build a village. This tributary that the town would be named for begins near Watkins, Minnesota, flows through a chain of lakes, and then enters Clearwater Lake before meeting up with the Father of Waters.

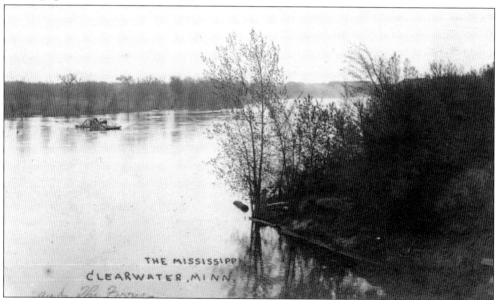

Besides building a sawmill, Stevens, Talbot & Company strung a ferry across the Mississippi in the spring of 1856. The ferry landing and the road that leads to Oak Street, the original business district, are still visible. The ferry changed hands many times over the years and was owned by Robert Lyons and finally by the Kirks.

Two

CONVERGING

The village soon filled up with eager pioneers who added needed skills to make a community flourish. Born in 1819, Jared Wheelock arrived in Clearwater in 1855 from Calais, Vermont. He became the first doctor in the area and surgeon of the board of enrollment of the Second District of Minnesota during the Civil War, headquartered in St. Paul. Throughout his life, Wheelock would play many vital roles in the shaping of early Clearwater.

Arriving in the late summer of 1855, Abigail Perkins Robinson Camp, a recent widow of George R. Camp and sister-in-law of Wheelock, was the first woman pioneer in the village. The daughter of Dr. Joseph and Hannah Robinson, she became the town's hotel housekeeper. Abigail married Thomas Porter a year later, in 1856. The couple had two children—Tarrant, who died at two years old, and Maud, who lived to be 103.

In 1856, Seth Gibbs arrived from Maine. Born in 1810, Gibbs set up a general store on the river. Later, he owned a sash, door, and blind factory. Clearwater must have been able to handle all the business, because two more general stores—one owned by Jeb E. Fuller, the other by William Tuttle Rigby—opened by the spring of 1857.

Born in 1822 and another Mainer, William John Kirk grew up to learn the harness-making trade. Once he settled in the Clearwater area in 1856, he worked as a farmer, liveryman, carpenter, and ferryman. His son William H. Kirk eventually took over the ferry business from his father.

Railroad man, bridge builder, and lumberman Francis Morrison was known around the state for his entrepreneurship in building up Minneapolis and Clearwater. He built a sawmill in the village in 1857. Morrison married Hannah Perkins, a relative of Abigail Perkins Robinson Camp Porter, Mary Wheelock, Tarrant Robinson, and others, in Stowe, Vermont. Morrison also built a hotel and named it the Morrison House, which operated for many years and claimed to offer some of the finest accommodations in the county.

This chapter will tell the story of the convergence of all these special individuals from small towns in Massachusetts, Maine, Vermont, and New York in the Minnesota Territory and how their unique talents and contributions helped create what would become the greatest place in the universe: Clearwater, Minnesota.

The first white woman in Clearwater, Abigail Perkins Robinson was born in 1819 in Vermont. She was invited to become housekeeper for the village hotel in 1855. The first meal she prepared was boiled potatoes and salt pork, laid out on a door held up by sawhorses. Abigail Camp married Thomas Porter. She died in 1909 from erysipelas, a skin infection.

The longest-functioning ferry across the Mississippi, Clearwater's early transportation system was a swing-cable operation. Begun in 1856 and located near the juncture of the Clearwater and Mississippi, it transported supplies, horse-drawn carriages, livestock, and people from one side to the other. William John Kirk and son William Henry Kirk were the first to man this water transport.

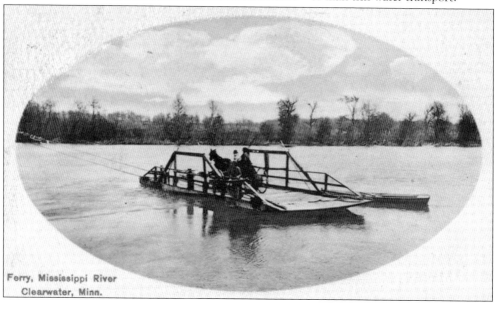

Ferry, Mississippi River
Clearwater, Minn.

The brother of Abigail Porter and Mary Wheelock, Tarrant Perkins Robinson, left Stowe, Vermont, with his wife, Sarah Louise Cutter, and they were living in the village next to Abigail and Thomas Porter by 1865. Born in 1835, Tarrant became a painter. He and his wife had two children. Sometime before 1879, he and his family moved to Minneapolis. Sarah died in 1900. Tarrant became a musician in his later years.

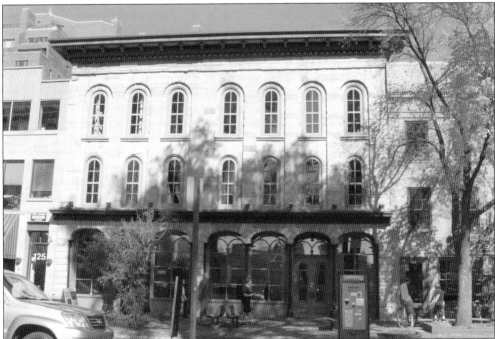

Francis Morrison was an industrialist—a railroad man, bridge builder, and lumberman—in Minneapolis. The edifice in this picture is still standing in St. Anthony. Built in 1858, the bottom floor contained a store, and the upper floor housed offices. Morrison also had a vision for Clearwater. He built a sawmill and the Morrison House, the nicest hotel in the county.

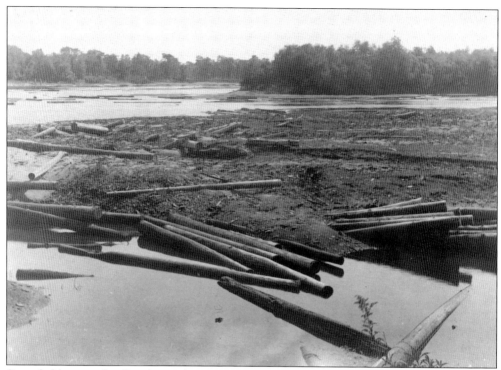

Stranded logs, or deadheads, as they were sometimes called, could be seen for years on the Mississippi once loggers started looking for the famous white pine. Francis Morrison and Thomas Tollington both owned and operated sawmills on the Clearwater River. Sometimes, there were so many logs that a person could walk across them from one side of the river to the other. Before owners sent their logs downriver, they stamped them with a distinct sign so that when they reached the sawmill they could be sorted and claimed. The September 9, 1892, *Clearwater News* states, "As soon as the river is cleared of the logs which at present time lines its shores, it is said that 600,000,000 feet will have floated down since the first of the season."

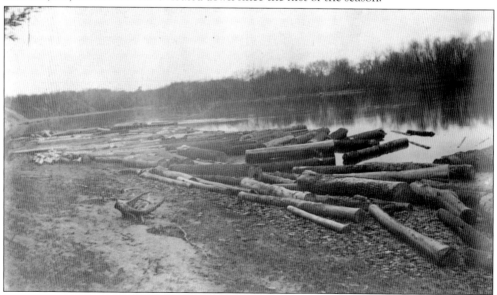

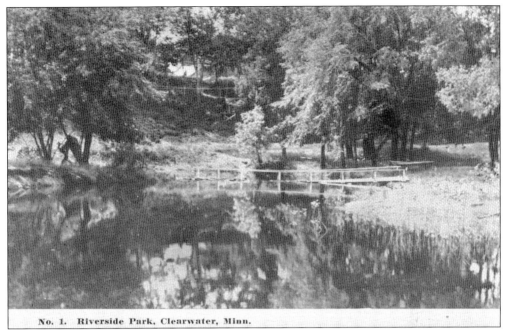

No. 1. Riverside Park, Clearwater, Minn.

Here in Lower Park, or Riverside Park, on the Clearwater River, the early village of Clearwater gave birth to business enterprises. Lined with sawmills, grain mills, and general stores, as well as Pat Quinn's Sample Room (saloon) and the town hall, this area was once a beehive of activity. The Oyster House (a boardinghouse) and the first hotel stood here as well. The river ends as it merges with the Mississippi. The footbridge aided citizens and visitors to get from one end of town to another all year long. A nasty flood in 1897 ended the business area here. Businesses relocated to Oak Street or Main Street after that.

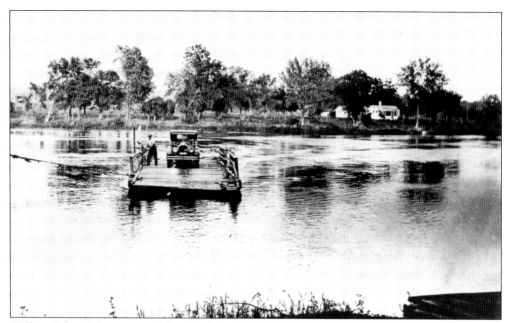

William John Kirk was one of the first ferrymen. Born in 1822, he grew up in Maine and learned the harness-making business. Once Kirk settled in the Clearwater area in 1856, he worked as a farmer, liveryman, carpenter, and ferryman. His son William H. Kirk eventually took the business over from his father. William H. Kirk is probably the one transporting Sherm Shattuck's Buick from Clear Lake to Clearwater.

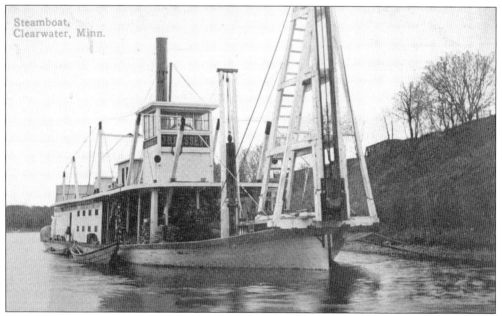

Steamboats have traveled the Mississippi since before the 1850s. The first to paddle past Clearwater was the *Governor Ramsey*. Others, including the *Cutter, Time and Tide, and J.B. Bassett*, pulled up to the riverbanks to unload freight and passengers. The Oyster House, owned by Stephen Oyster, and the Stevens and Farwell hotel, for which Abigail Camp Porter was housekeeper, stood close by overlooking the Clearwater River.

Three

STRONG CURRENTS

Others joined the throng of industrious pioneers to help build a thriving community. Thomas Tollington sailed from Liverpool, England, in 1857 and arrived in Buffalo, New York. From there, he and most of the family moved to Will County, Illinois. There, he married Sarah Jane Pauley from Pennsylvania. By 1857, the couple had moved to Clearwater, and Thomas became a sawmill operator as well as a partner of Seth Gibbs in a sash, door, and blind factory. After returning from service in the Civil War, he was known as a furniture dealer, cabinetmaker, and undertaker.

Samuel Whiting, a friend and college classmate of future president James Garfield, received an extensive education in Connecticut and New York, including the opportunity to read law under Thomas C. Perkins, son-in-law of preacher Dr. Lyman Beecher, the head of the famous Beecher family of Hartford, Connecticut. Admitted to the Minnesota bar, he opened the Whiting Brothers dry goods store with his brothers.

Best known for his time spent at Andersonville during the Civil War, Maj. William Wallace Webster was born in Sherbrooke, Quebec, in 1832. He arrived in Clearwater in 1857 and began working for the townsite before enlisting in the 3rd Minnesota Volunteer Infantry. Once released from his military duties, he returned to his store, where he worked for the rest of his life. Webster and Henry "Hod" Webster were brothers.

Robert Shaw shared the distinction of being one of the earliest pioneers in Clearwater, arriving in 1856 and building up clientele for his shoe store and repair shop. Leaving Pennsylvania, he and his family moved to Ohio, where he learned the shoemaking trade. Shaw married Sarah Johnson from Ohio in 1855 and was a lifelong Mason.

Another person hailing from Stowe, Vermont, George B. Benson arrived with his family in the village in the spring of 1860. Born in 1824, he grew up on the family farm before entering the freighting business. Benson farmed in Lynden Township but lived in town, and at times, he worked as landlord of the Morrison House.

The groundwork laid by these pioneers, many of whom also served in the Civil War, and those who followed shortly after paved the way for others to seek out a life in Clearwater. Newcomers from Pennsylvania, Connecticut, Ohio, and Canada would go on to plant roots in the area, build homes, establish businesses, and assume roles that would shape the economy and culture of this burgeoning territory.

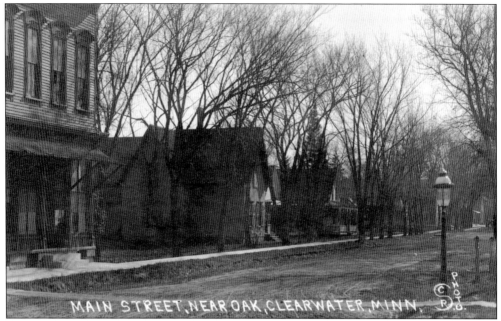

MAIN STREET, NEAR OAK, CLEARWATER, MINN.

Samuel Whiting was educated in the East, where he was born in 1831. He made friends with future president James Garfield. After he passed the bar, he came to Clearwater in 1857. Whiting established himself in business. He was appointed to the Wright County Board of Supervisors for a number of years and built the Whiting Building, on the left, operating a clothing store there. He also opened the top floor for temperance meetings, local theater, and even vaudeville acts.

Born in England, Thomas Tollington came to Clearwater before 1858. He commenced establishing himself in the sawmill trade and ran one of the three water-powered mills on the Clearwater River. He also owned a furniture and cabinet factory and a sash, door, and blind factory and became a specialist in undertaking. During the Civil War, Tollington was a captain in Company E of the 8th Regiment.

Born in Quebec in 1832, William Wallace Webster came to Minnesota in 1858. He filed for a claim and worked for the village of Clearwater until he took a job as an agent for the Freight and Transportation Company in St. Anthony. In 1861, he enlisted in the Army, afterwards being captured and serving time in Andersonville. Before he was discharged, he was awarded the rank of major. Returning to Clearwater, he was appointed a Wright County supervisor. Webster spent the rest of his life in the mercantile business in Clearwater, selling everything from hats, caps, and shoes to teas and coffee. He was a Grand Mason, a charter member and secretary of the Clearwater Lodge, and a member of A.C. Collins Post of the GAR. Webster built this home on Bluff Street, which is listed in the National Register of Historic Places.

Peter Leme was an instrumental man in Clearwater who built the brick hotel on Main Street and a house next door that was sold to Dr. Ernest Kingsbury and later to the K.C. Miller family. Dr. Ira Edmunds was also an influential physician. He lived on Bluff Street and doctored many around the Clearwater area. His wife was Augusta Tollington, daughter of Thomas and sister of Dr. Gilbert Tollington. L.C. Johnson was an early grocer.

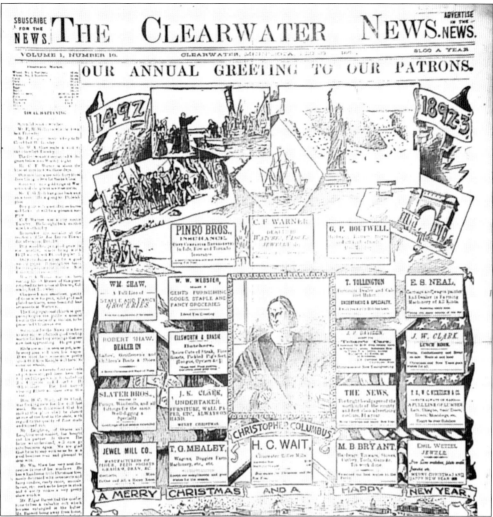

In an 1892 *Clearwater News*, this was the first annual Christmas greeting from local businesses depicting what they sold. This wonderful advertisement display shows that Clearwater is alive and doing business. William Shaw sold groceries. C.F. Warner sold watches and jewelry. George Boutwell had the hardware store and sold stoves, paints, nails, and anything a settler needed to get started. William W. Webster sold groceries and dry goods such as shoes, caps, hats, and gloves. Thomas Tollington had furniture and built caskets. The Pineo brothers always sold insurances, although they often sold other goods. Mealey made buggies, and J.K. Clark was also into the furniture and undertaking business. Other businesses included Wetzel Jewelry and Jewell Milling for flours and other grains to be sold and marketed. No wonder the surrounding communities believed that Clearwater would eventually become a metropolis.

Owned by Henry Chester Waite (or Wait), the Clearwater Roller Mills kept locals and the huge Twin City grain market well supplied. Advertising the best flour provided by the best farming operations around Clearwater, it was located at the mouth of the Clearwater River. H.C. Waite claimed that he offered the finest prices for wheat. E.S. Neal Carriages is listed in the 1891 *American Carriage Directory* as one of the best carriage and wagon builders in the area. He is also listed in the *Minnesota, North and South Dakota and Montana Gazetteer and Business Directory* as a wagonmaker in Maine Prairie, Stearns County. D.B. Pineo is listed in the same gazette as a repairer.

Waite Park, a suburb of St. Cloud, was named for H.C. Waite. Born in Rensselaerville, New York, in 1830, Waite was admitted to the bar in 1853. He arrived in St. Cloud in 1855 and became a banker. He became registrar of the US Land Office and the first lawyer in St. Cloud. A true pioneer, Waite owned 640 acres in south St. Cloud, living there until he died. He had mining interests in northern Minnesota and was a member of the state constitutional convention held in 1857, a state representative, a state senator, and owner of Clearwater Roller Mills and Cold Spring flouring mill. Waite married Maria D. Paige in 1860. Their son Clark Waite took over the farm after his death and was an owner of a granite works.

CLEARWATER NEWS.

CLEARWATER, MINNESOTA, JAN. 6, 1893. $1.00 A YEAR

DAVIS RENOMINATED.

Eighty-Eight Republicans in Caucus Pledge Themselves to Davis.

Eight Republicans Refuse to Go Into Caucus.

(Special to The News.)

St. Paul, Jan. 5;—For a week a vast horde of democratic politicians, aided by an unseen but mighty force, from inside republican councils, have been at work to compass the defeat of Senator Davis. Every effort has been made to prevent a republican caucus, or at least to keep enough republicans out so that there should not be a majority of the legislature there, but their schemes have come to nought, and they have signally failed. At the caucus last night 86 republicans, two more than a majority of the entire legislature, answered to their names, and voted for Senator Davis. H. E. Craig of Sherburne county was sick in bed, but sent a written communication asking that his vote be counted for Davis. J. A. Holler was another who remained away, and in an interview later with your reporter, says that he be fully intended to be present, but was unavoidably detained, and further announces that he shall cast his vote for the return of Mr. Davis.

Among the great horde of democrats here working for a schism in the republican ranks were Bull of Cokato, as slick as grease, and Harwick of Sherburne county. They have had their pains for nothing, and returned home to-day, chagrined and disappointed men. Davis will be elected on the 17th inst., and will undoubtedly get the entire vote of the 96 republicans now that...

...was to debate. Salaries of cloak room keepers were reduced to $2 per day, and, after the appointment of a committee to wait on the governor and governor-elect the senate adjourned to 10 a. m.

THE SECOND DAY.

St. Paul, Jan. 4.—After the roll call Mr. Fleming moved that the reading of the house journal be dispensed with, but Greer objected, as he said there were a number of errors. After the journal was read and corrected O. B. Turrell, of the committee appointed to notify the governor and governor-elect, announced that they desired to meet the legislature in joint session at 12 o'clock. It was decided to hold the session at that time, and the old committee was continued.

Mr. Boggs offered a resolution providing that members of the last house who are members of this be allowed first choice of seats.

Mr. Hopkins moved an amendment to the effect that the resolution include all the aged members of the house, whether new or old. Mr. Turrell also favored this and the amended resolution was adopted.

The speaker was authorized to appoint a committee of five on rules.

At noon, according to programme, both houses assembled in joint session and listened to the reading of Governor Merriam's message. That finished Governor Nelson's first message was read.

GOVERNOR NELSON.

He Was Inaugurated at Noon Wednesday, Jan. 4, and His First Message...

State Institutions

The governor urges that provision be made for leasing convict labor on long time contracts. The building twice industry in the Stillwater prison is in good condition and will become of advantage to Minnesota farmers.

The lunacy commission should have greater powers and the insane asylums improved, especially at Fergus Falls.

The state board of health should have more money at its command.

A new state capitol building should be provided for; the world's fair commission should have additional support, and state swamp lands should be deeded to whoever is entitled to them.

Financial institutions should be required to pay a small fee to pay for help needed by the bank examiner.

A State Park.

The question of a state park around the headwaters of the Mississippi river should be settled. The state can now acquire the park site, 19,791 acres, for almost nothing.

State finances are in satisfactory condition. The state treasurer should give bond for a larger amount. The state tax levy for next two years might be reduced by eight-tenths of a mill, and thus save $199,099 each year for 1894-95.

NEWS' CHIP BASKET.

It is said to have cost the present emperor of china $10,000,000 to get married.

It is stated that one-forth of Scotland is owned by thirteen persons.

China's bells were made by Paul ros, an Italian bishop, to drive away demons, about 400 A. D.

Hattie Bursell Shirley, also known as H.E. Shirley, took command of her husband's store after his death in 1891; she became a sound businesswoman. She sold groceries and notions and took trades on eggs and butter. Hattie's shop was located on the lower level of the Masonic hall. Stanley Phillips, born in New York, owned S.M. Phillips Drug Store. At one time, he was located on Oak Street, but before 1895, he had moved his business to Main Street, and his daughter, Jennie Phillips, apprenticed under him. She attended Dr. Drew's Drug School in the Twin Cities, graduated at the top of her class, and earned her druggist's license.

Mary Elizabeth Dunklee from New Hampshire was born in 1847. She married Dexter Collins, who was born in 1834 and was also from New Hampshire. He owned and operated a blacksmith shop on Ash Street. Mary's father, Chester Dunklee, was born in Vermont, moving to New Hampshire before he and family settled in Silver Creek Township.

This Merrick's Thread card is an advertisement from the L.C. Johnson store. Lorenzo Johnson settled in Lynden Township in 1856. Soon after, he opened his general store, dealing in groceries and dry goods. The 1880 Minnesota census indicates that Lorenzo and his wife, Adeline Johnson, were both 59 and born in New Hampshire. The couple was married in 1848 in Lowell, Massachusetts.

Logging continued as a major economic boon for the community. Log drivers let the current of the Mississippi River move logs downstream to Clearwater's sawmills and pulp mill. It took a crew of men to spot how each log was moving and keep all heading in the right direction to prevent a logjam.

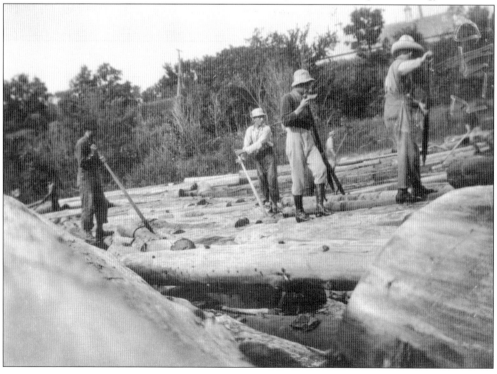

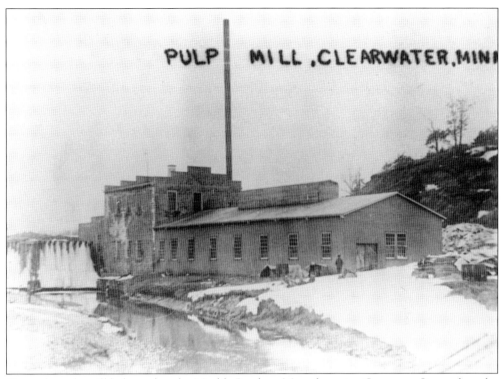

Once, the pulp mill belonged to the Muckle Brothers Manufacturing Company. Situated on the Clearwater River, it turned wood chips or plant scraps into pulp to make paper, stick matches, and even cigar boxes. Construction began around 1907, but this mill was shut down around 1915. The Great Northern Railway Company received permission to remove its spur track for loading and unloading, no longer in use at the pulp mill in Clearwater. The *Clearwater Herald* advised the public of a meeting scheduled for January 28, 1918, to be held at the Clearwater Hotel to discuss this. By 1919, Henry Claude Muckle, one of the owners, had died in Wisconsin. The company was transferred to the father's business, the Muckle Manufacturing Company, in Minneapolis and St. Paul. Below is the inside of the pulp mill.

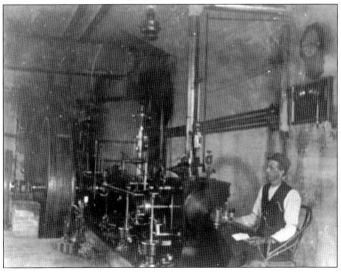

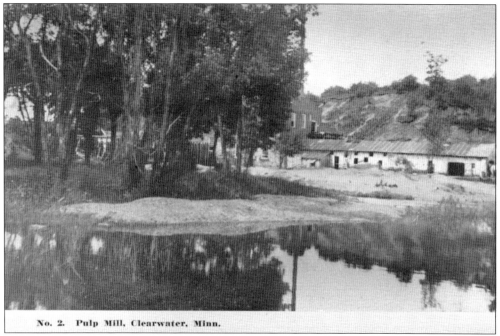

This image shows another view of the Muckle Brothers Pulp Mill and how it was situated by the Clearwater River. Due to all the different milling operations, the course of the river changed many times The Muckle family came from Whitney Point, New York. Henry and Hattie May Church Muckle moved from New York to Minnesota before 1887 with their five children.

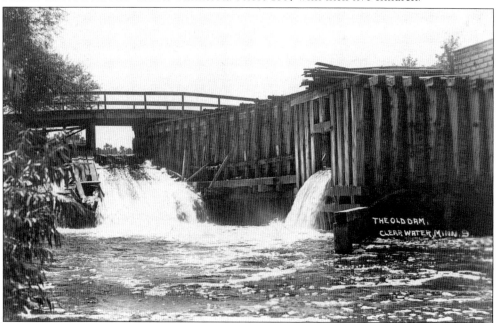

The water from the Clearwater River was substantial enough to provide power for the dams that worked the sawmills, flour mills, and pulp mill. One dam was located a mile north of the village at Fremont City. Another, referred to as the lower dam, was located close to the Mississippi to run the flour mill. This picture shows the middle dam and mill bridge.

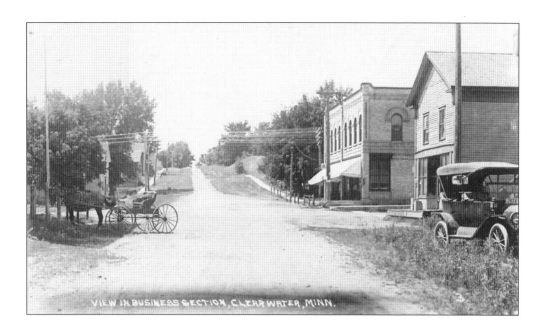

VIEW IN BUSINESS SECTION, CLEAR WATER, MINN.

Soon after the founders located in the village, they platted out the streets. At the confluence of the Clearwater and Mississippi Rivers, Oak Street (above) welcomed those individuals who drove or stepped off steamboats or the ferry. Here, they could find lodging, hardware, groceries, clothing, furniture, a quick beer, and even jewelry. A fire in 1895 burned a number of buildings. On the left stand Quinn's Saloon and the Whiting Building. On the right are Boutwell's Hardware Store and the Masonic lodge. Main Street (below) began to get built up as more people moved into the village. Phillips Drug Store is on the right. A livery stable moved in next door, and farther down was a blacksmith shop. Across the street were Hotel Clearwater, Leme's Hotel, and later Scott's Hotel.

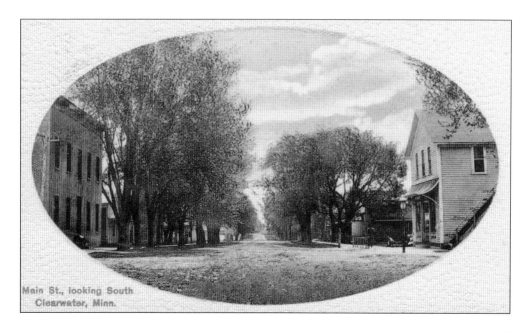

Main St., looking South
Clearwater, Minn.

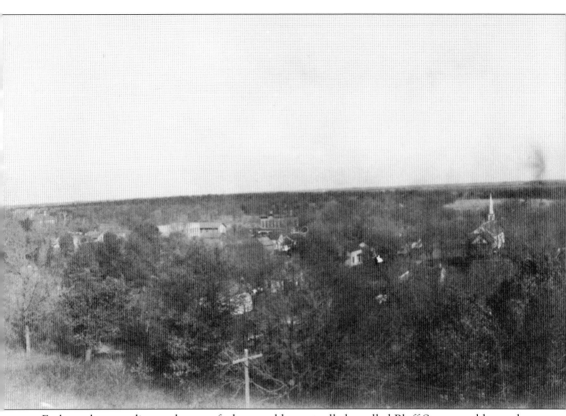

Early settlers standing at the top of what would eventually be called Bluff Street could see what this area offered them, alive with timber for harvesting and prairies for farming, all surrounded by

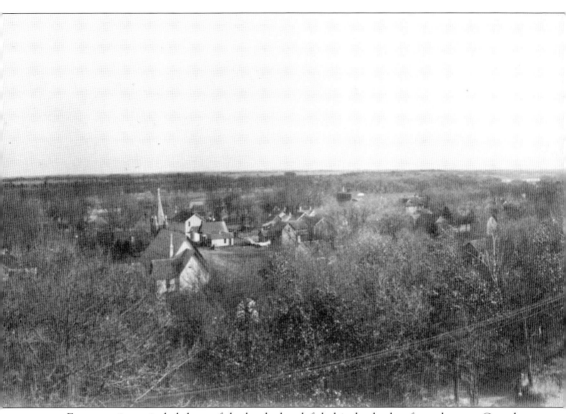

water. For some, it reminded them of the lands they left behind, whether from the east, Canada, or even Europe.

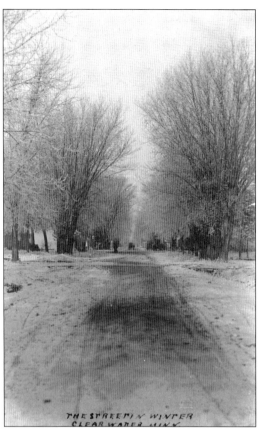

This is Main Street in winter. The back of the card is stamped January 22, 1908, and the sender states there is not much snow. A horse-drawn carriage is coming down the middle of the road. Other teams are tied up in front of various enterprises.

THE STREET IN WINTER
CLEARWATER MINN

Luther Laughton, his family, and his horse are standing outside the home. Thomas Tollington and Simon Stevens built this house as early as 1859. Luther moved with his family from Maine, settling in the Big Bend area first. Luther was the butcher in town for many years. In the 1910 federal census, he is also listed as a stock buyer.

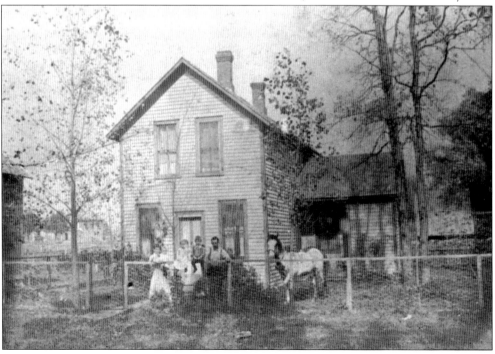

Born in 1848 in Allegany, New York, Stanley McClure Phillips worked on the family farm until 1868, when he, his parents, William Hulburt and Lemira McClure Phillips, and their other children moved to Clearwater. Stanley married Maryetta Crossman. The couple had 10 children, two dying in infancy. He was a teacher, grocer, and hardware man until he became druggist of Phillips Drug Store, located first on Oak Street and later on Main Street.

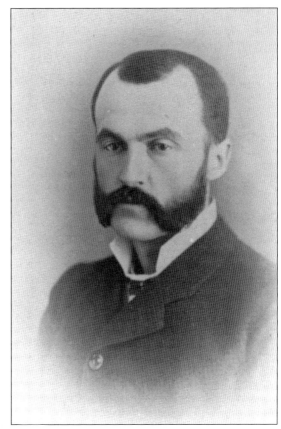

Phillips Drug Store was located in this two-story edifice with large bay windows. Stanley Phillips relocated the original business, once owned by Phillip Schwab. Here, he and daughter Jennie sold patent medicines as well as prescriptions written up by local doctors. In addition to being a drugstore, the structure also housed the post office. Stanley became the postmaster, a position he kept until his death in 1903, when Jennie took over.

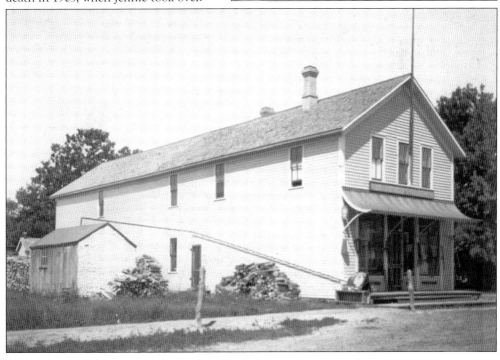

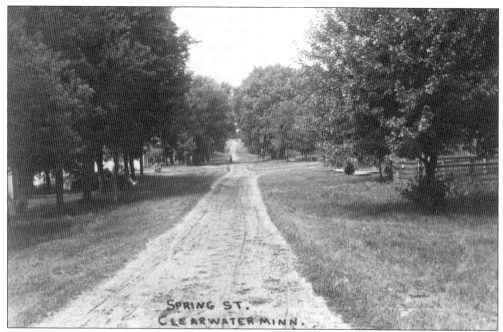

Some homes had begun to be built on Spring Street, which ran south-to-north. In this picture, a pen for keeping in livestock such as a cow or chickens is on the right. By 1904, St. Luke's Catholic Church was built on the left at the intersection.

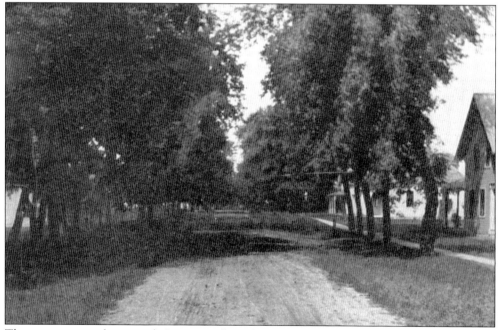

This picture was taken outside Dexter Collins's home, located on the left. The message on the back was written by his wife, Mary Elizabeth Dunklee Collins, to a cousin in Vermont. She states that she lives on this street. She goes on to say the trees are so thick that "you cannot see the houses on each side." The house across the street on the right belonged to Stanley and Maryetta Phillips.

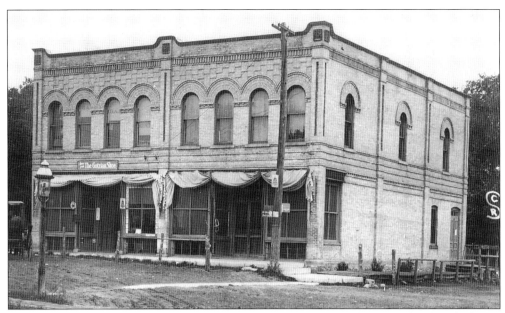

Clearwater realized its need to organize a Masonic lodge. In 1858, the group developed a burial ground, naming it Acacia, and erected a lodge. After a fire, it was rebuilt in 1888 with the yellow brick common to St. Cloud. The Masons used the top floor for a lodge and rented out the bottom. It sits on Oak Street and is listed in the National Register of Historic Places.

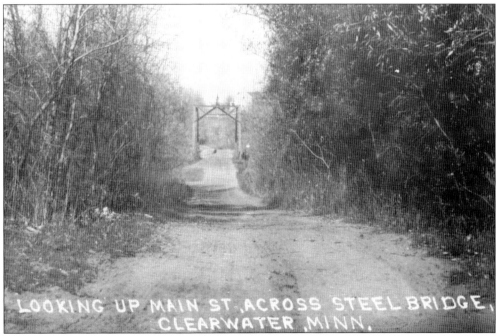

Even in the early days of the village's development, taxes were necessary to build roads, schools, and bridges. The three bridges on the Clearwater River were built by the town without much help from Wright County. This wagon bridge crossed the Clearwater River from Main Street into Lynden Township, Stearns County.

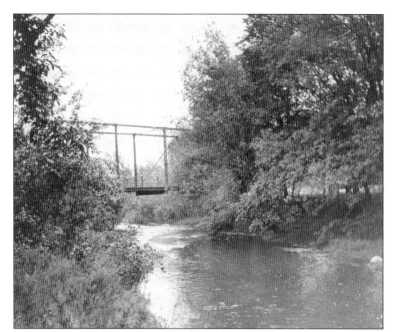

Almost an idyllic view of the Clearwater River with the wagon bridge, this picture shows the natural beauty surrounding this part of Minnesota. The river waters offered industry as well, from fishing to pulp and grain mills. Perhaps this view of Clearwater is the reason many people were drawn here.

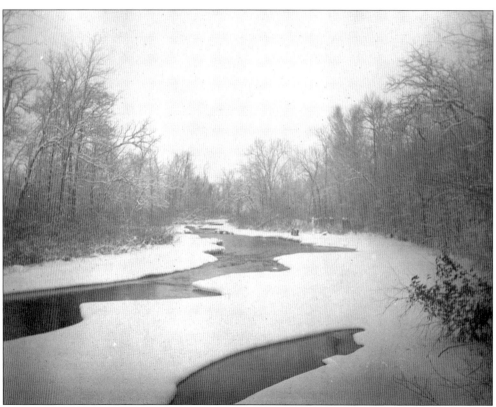

The Clearwater River provided ample views from its source to its mouth year-round. It seldom froze hard enough to walk across safely because of the speed and force of the water flow toward the Mississippi. The footbridge had to be used if it was clear of water and ice.

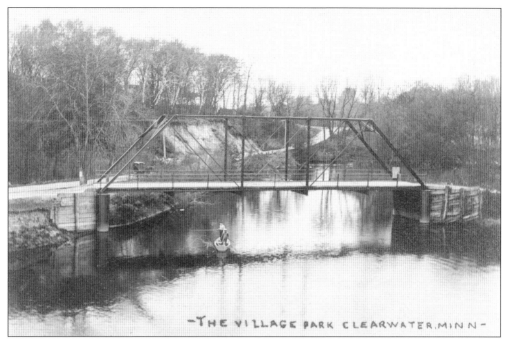

-THE VILLAGE PARK CLEARWATER, MINN-

This view of the bridge crossing the Clearwater River depicts the area that would eventually become Lower Park once the river flow was changed and a new dam was built. Thomas Tollington's sawmill and furniture and sash factory once stood nearby. He built his home on the hill to the left. Below the bridge, two people fish in a boat, and near the bridge stand a horse and buggy.

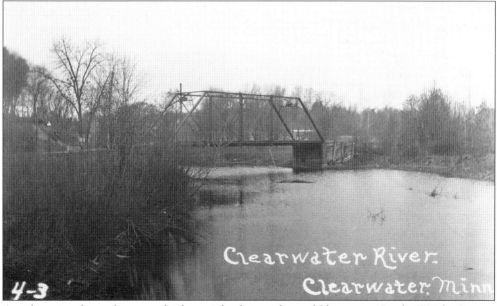

Clearwater River. Clearwater, Minn

4-3

Another view shows the wagon bridge as it leads in and out of Clearwater. On the Wright County side, a lamplight is visible on the left. In the distance, on the Lynden Township, Stearns County, side, the pulp mill chimney peeks out and the roofs of mill sheds shine through the bridge, while a house stands on the far right.

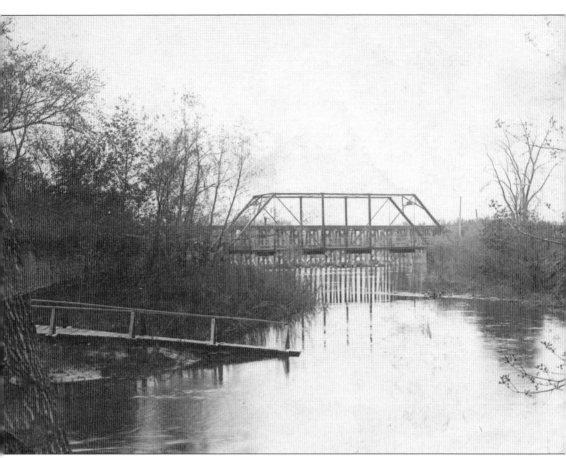

This gives a different perspective of the wagon, or iron, bridge with the railroad trestle behind it. The village was an active and loud place, with rural people coming into town to buy supplies or send off produce or livestock. The Great Northern also kept the flow of industry moving.

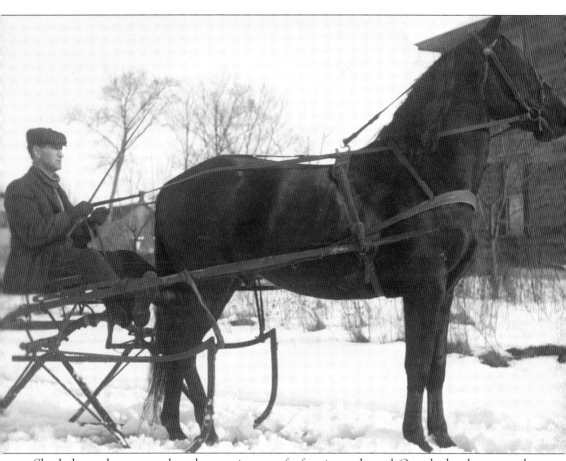

Slowly, horses began to replace slow-moving oxen for farming and travel. Oxen had endurance and strength, but they were not as smart as horses. Oxen could not be ridden but often ran away from their owners. Horses could be trained, ridden, and driven, and were attached to their owners.

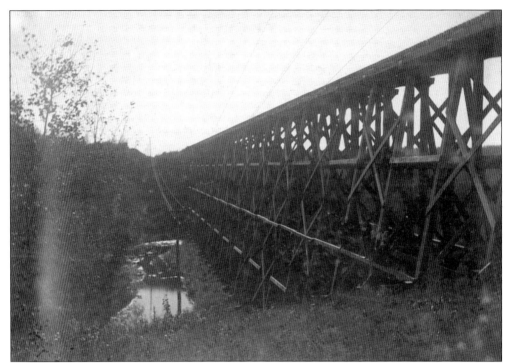

Plans were underway by 1847 for railroads to run through the territory, but not until Minnesota became a state did *The William Crooks* locomotive run from St. Paul to St. Anthony. This picture shows the original train bridge that spread across the Clearwater River.

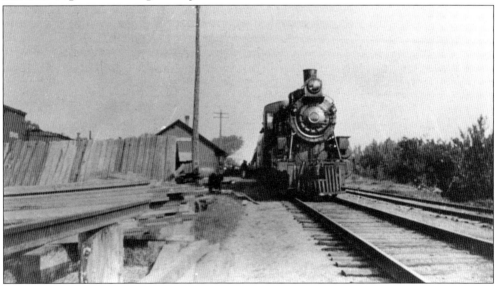

James J. Hill possessed ingenuity and knew opportunity when he saw it. Born in Canada, Hill moved to St. Paul when he was 18, taking a job managing freight for rail and steamboat. He learned the business well and by the Panic of 1873, he had enough capital to buy up bankrupted railways. By 1882, the first engine pulled into Clearwater. This picture with the depot on the left depicts the engine heading toward Minneapolis. This service changed the course of many communities, connecting villagers to a wider world.

Four

Surrounding Habitats

Many early settlers helped with the development not only of Clearwater but also with other communities around the village. Fremont City, laid out in 1856 approximately one mile southwest, was named after John C. Frémont, an explorer, soldier, and politician. Here, early developers such as William McDonald and Seth Gibbs planned for another mill town. Soon, other buildings besides flour and sawmills cropped up, including a hotel. However, by 1863, Fremont City had all but closed due to unpaid taxes.

Clearwater Township stretches east, west, and south of Clearwater. Selah Markham was the first to settle the area. Those who settled close by resided at what they called Big Bend, three miles southeast and around a crook in the river from the future village of Clearwater. In 1855, the census taker counted 62 men and women residing in the area—all farmers, and each supporting education. In fact, the first school in the county was conducted at Big Bend during the summer of 1856 and was taught by Ellen Kent. Others who settled here early on include the Rices and Sheldons.

The township first named Delhi but later renamed Corinna hugged both Pleasant and Clearwater Lakes and contained most of the water sources in Wright County. The Sioux and Ho-Chunks (Winnebagos) enjoyed hunting and fishing opportunities and often camped within its boundaries. Early families, including the Dakins, Dobleses, Townsends, and Days, added to an increasing agricultural community. Octavius and Phoebe Longworth pioneered in the area as well. They built a cabin and cleared the woods around their claim with oxen. The couple developed their property into the well-respected Longworth Resort.

Allied to Clearwater but located in the southeast section of Stearns County, on the other side of the Clearwater and Mississippi Rivers, Lynden Township provided productive land, farmers, and educators. Encompassing many lakes, streams, and creeks, the eastern part of the township was settled in 1856. Some of the names from Lynden include Colgrove, Heaton, Ponsford, Storms, Stokes, Stewart, Townsend, Mitchell, Porter, Quinn, Lyons, Warner, and Oyster.

The development of these surrounding communities was vital to the diversity of Clearwater's economy. The interaction of these separate but similar populations allowed for an unprecedented exchange of goods and ideas. The burgeoning demand for goods and services and the ample supply of land created opportunities in Clearwater and its surrounding areas that could be matched by few areas in the country.

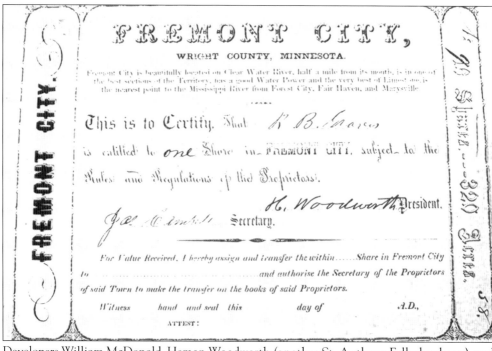

Developers William McDonald, Heman Woodworth (another St. Anthony Falls developer), and Seth Gibbs planned for Fremont City to become a mill town. Born in Boston in 1832, James Cambell built the first flour mill in 1861. After a few years, he moved to Poughkeepsie, New York, to become a manager of Vassar College. By 1870, the mill building had burned down. C.F. Davis and Lewis Clark, developers at Fremont City and Clearwater, rebuilt the mill and the dam. This water and power source became an important commodity in the early development of Clearwater. Other buildings besides saw- and flour mills cropped up; McDonald built a hotel. Unfortunately, by 1863, Fremont City had all but closed due to unpaid taxes. Below is the flour mill, which was moved across ice from Fremont City to Clearwater. Stephen Oyster was a miller at the Fremont Mills and later at the Clearwater Roller Mills.

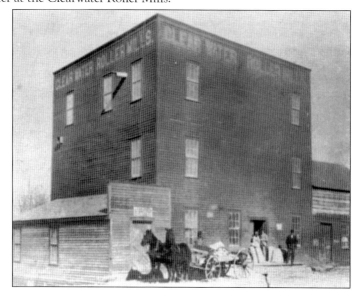

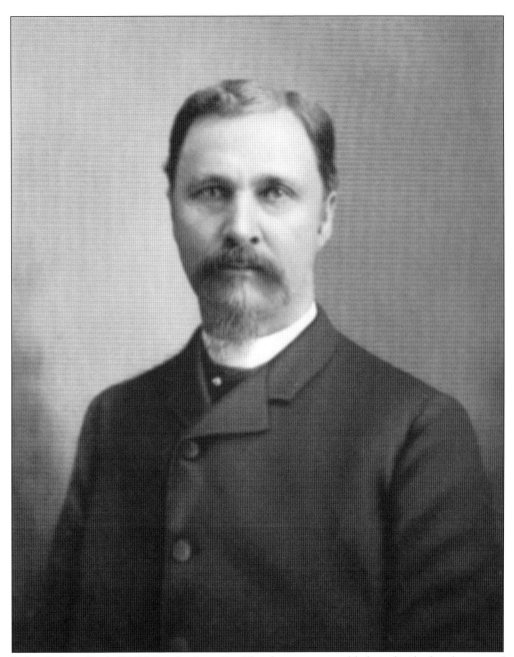

Judge Dolson Bush "D.B." Searle, from St. Cloud, seems an unlikely individual to be part of Clearwater's early days, but after the death of C.F. Davis, he purchased the Davis estate, which included the Fremont mill and the waterpower rights. He sold the property to H.C. Waite & Son. Searle was born in New York in 1840. He served in Company I of the 64th New York Infantry during the Civil War, engaging in the Second Battle of Bull Run and the Battle of Antietam. Searle attended the Ford Theater the night President Lincoln was assassinated. He graduated with high honors from the law school of Columbian College. Once located in central Minnesota, he became an influential and respected attorney and judge interested in people, politics, education, and justice.

Curtis D. Shattuck was born in 1824 in New York. Because his father was disabled in the War of 1812, Curtis ran the farm, chopping wood and making shingles for roofs. He married Amanda Day, who was born in Vermont in 1849. He and his family settled on 120 acres in Clearwater Township. For years, Curtis was the town treasurer. Both husband and wife had family that helped build up the area around Clearwater. Amanda's brother, Westel Willoughby Day, came to Minnesota earlier, first settling in Excelsior. After two years, he moved to Fremont, near Silver Creek, and set up a sawmill. Amanda's sister Sarah married Curtis's brother Chauncy and farmed near Clearwater. Sister Augusta married Harvey Barrett and settled near Clearwater. Another sister, Betsey, came with her husband, Thomas Mullholand, settling in Clearwater Township. Curtis and Amanda had four children.

Willard Rice, the son of Clark and Emily Draper Rice, moved from Wisconsin with his family in 1879. His parents, Vermont natives, settled on a farm in Clearwater Township. Born in 1857, Willard became independent as early as 16, when he became a farmhand and logger in Wisconsin. In Minnesota, he helped his family establish themselves on the farm before he bought up land near them in 1891. He married Elmira Brandow, also born in Wisconsin, in 1893. The couple had one son, Leroy, who helped with the family farm. The nucleus of this family and the Drapers is written up in the article "They Are All One—Marriage Has Made Everybody in Clearwater a Member of the Same Family" for an 1888 issue of the *Wright County Times*. The author links these families to the Sheldons, Mitchells, Whitneys, Merrills, Traftons, Bentleys, Hyatts, Humphreys, Shaws, Barretts, and others.

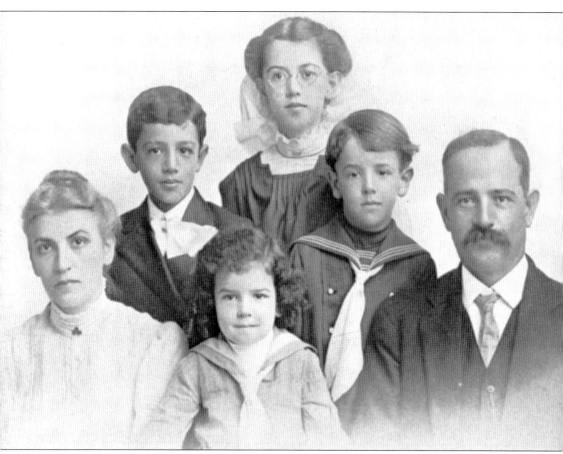

Born on the family farm in 1869, William H. Lee was one of James and Rebecca Burcham Lee's six children. The parents were some of the earliest settlers in Wright County. James Lee was born in Delaware in 1827 but moved his family to Springfield, Illinois, home of Abraham Lincoln. In 1897, William married Anna Kothmann. She was born in 1868 to Francis Kothmann, who emigrated from Prussia. Francis's first wife, Eliza, born in Germany, died in Clearwater in 1862. The couple had three children. Francis, a blacksmith and farmer, then married Katherine Unger, who was born in Prussia in 1837, emigrating when she was 20. The couple had seven children, one being Anna Lee. William took over the family farm in Section 22 of Clearwater Township. He and Anna raised five children and helped establish the Clearwater Episcopal Church. Pictured here are William, his wife, Anna, and their children Kathryn, Walter, Arthur, and John.

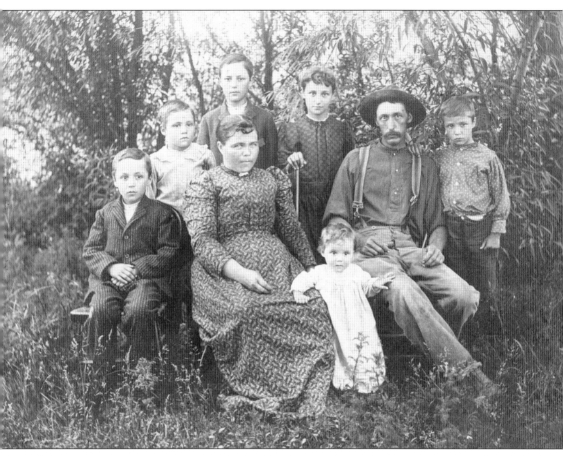

The Sheldon family around Clearwater can trace their roots back to a common ancestor, Col. Elisha Sheldon, born in 1740, who fought in the Revolutionary War. Elisha Sr. married Sarah Bellows, also born in 1740, in Connecticut. By 1789, they, their sons, Elisha Jr., George, and Samuel, and their families had moved from Connecticut to Vermont, where they bought a village established as Hungerford, renaming it Sheldon. The colonel and Elisha Jr. held town management positions, while Samuel served as justice of peace and in the Vermont legislature. The Sheldons settled in Wisconsin, but the Nelson Sheldon family made Clearwater their home sometime before 1875. Pictured in this classic pioneering photograph is Nelson and Lucy Draper Sheldon's son George Nelson with his family: Otis, Levi, Oliver, Inez, Loyal, Mary Ann Wells Sheldon, Evelyn, and George Nelson. (Courtesy of the Sheldon-Tesmer families.)

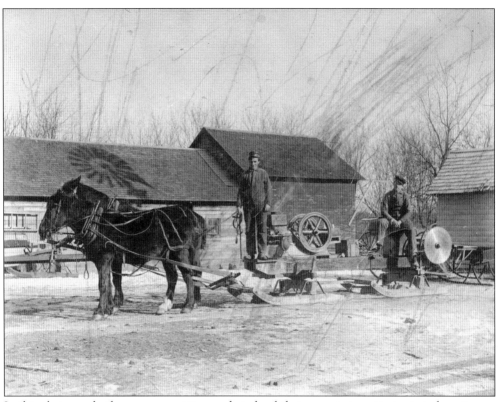

In this photograph, the men are getting ready to haul their saw rig to a site to start chopping up timber. This invention saved many backbreaking hours of chopping by hand with an ax. Oscar Hoglund from Silver Creek Township owned this operation. Otis Sheldon is also posing for the picture.

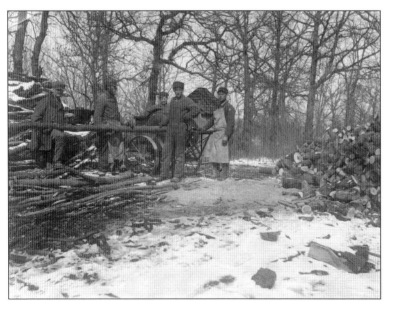

Those who came to Minnesota to develop farms learned quickly they had to tackle part of the Big Woods before they could conquer the virgin land to grow crops. In this picture, men are working a saw rig, or a portable sawmill. The wood is cut up and used for firewood or for building material.

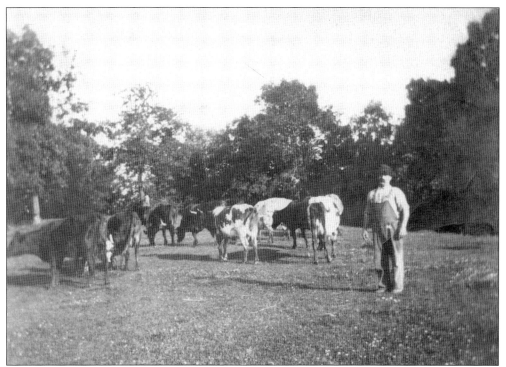

When the 13th federal census was tallied, Wright County counted nearly 50,000 cattle, 28,000 dairy cows (not including 7,000 calves), over 10,000 yearlings, and 3,000 steers and bulls. Their total value was over $1 million. John Pearson, whose daughter Ebba married Levi Sheldon, is posing here with a number of his cattle. (Courtesy of the Sheldon-Tesmer families.)

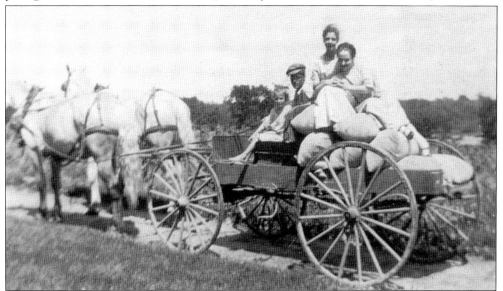

This scene is an example of a big event, when a family went to town to either sell grain or have it ground into flour. The sold grain helped pay the bills and buy goods like coffee and sugar. If these are sacks of wheat that are going to be made into flour, they were probably sold at one of Clearwater's flour mills. (Courtesy of the Sheldon-Tesmer families.)

The 13th federal census registers 251,000 poultry in Wright County, worth $119,000. The feeding of chicken, ducks, and geese usually fell to the wife or children in the family. All could be butchered for Sunday dinner, but chicken eggs could also be sold or even traded for credit at Hattie Shirley's Mercantile Store below the Masonic hall. (Courtesy of the Sheldon-Tesmer families.)

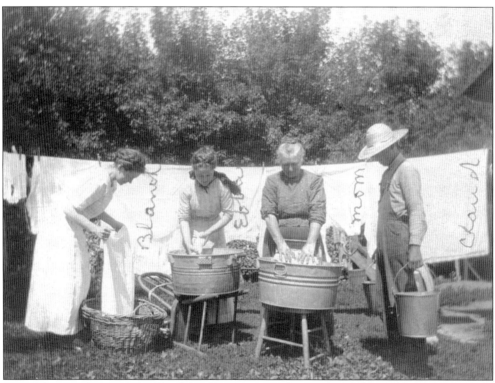

It must be Monday. Most families kept their routines almost religiously: wash on Monday, iron on Tuesday, mend on Wednesday, and so on. Blanche Pearson Miller, Ebba Pearson Sheldon, and mother Hannah Pearson are scrubbing, rinsing, and hanging. Whoever was not needed to do chores or help in the fields had to haul water. Here, Claud Pearson is waiting to pour the water buckets into the washtubs. (Courtesy of the Sheldon-Tesmer families.)

The only tool missing from this picture is the pitchfork. Hive-like straw piles were a common sight around Clearwater. Straw contained little nutrition, because it was the waste product of threshed grains like wheat, oats, barley, and rye. It was used for livestock bedding, insulation of houses, roofing, and when times were tough and wood was scarce, it was used for burning to keep the house warm.

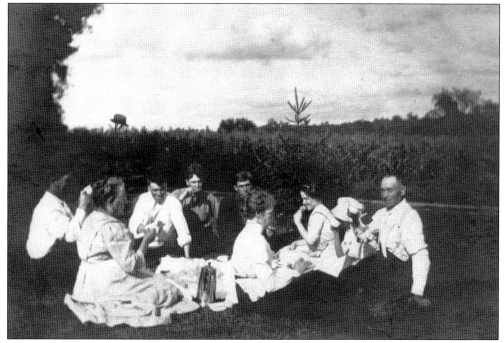

Sunday was a day of rest. Although some chores, like milking, had to be done after church in the summer, families often enjoyed the outdoors by having a picnic. This picture was taken in late summer, because the corn is high. A bowler hat, or derby, rests on a twig. The family is wearing their Sunday best. (Courtesy of the Sheldon-Tesmer families.)

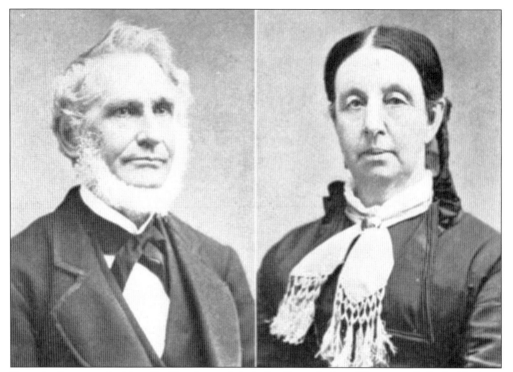

Octavius Longworth, his wife, Phoebe, and their family settled on Clearwater Lake in Corinna Township in 1859. Octavius, born in 1805, came from an established New York City family. His father, David, owned Shakespeare Gallery, a publishing company. In the 1850 census for New York, Octavius is listed as owning a book and stationery store and as postmaster of Brooklyn. Phoebe was born in 1809 to Col. John Wade and Sarah Lyon Wade of New Jersey. Once the Longworths arrived in Corinna, they cleared trees and dug and sold ginseng until their financial status improved. Two elder sons served in the Civil War, one staying until the conclusion and the other dying in battle. Daughter Sarah married a Clearwater Township farmer, Cyrus Smith. Octavius and Phoebe built and operated the Longworth Resort.

Pictured here is the peaceful Longworth Resort, located by the shores of Clearwater Lake. With 16 cottages, it could house nearly 100 visitors. Those who swam here, played tennis, fished, or just lazed around experienced some of the finest cuisine offered in Minnesota. Eventually, it was sold to the Tuelles, Beechers, and finally, Camp Friendship, a summer camp for handicapped children.

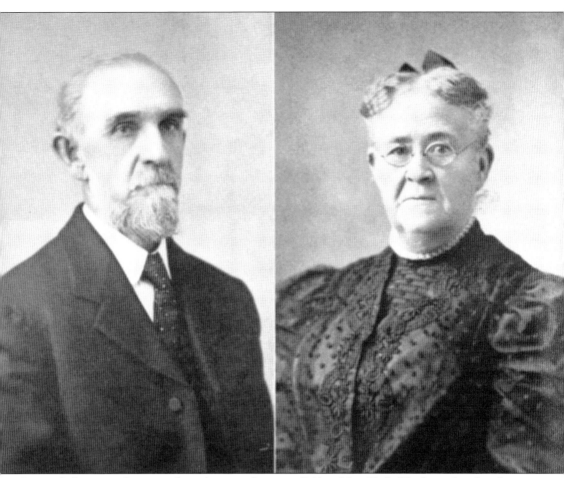

James Colgrove, a farmer and teacher, was born in 1841 in New York. He farmed in Lynden Township, Stearns County, in 1866. There, he increased his land to 400 acres and became an influential and respected man in the area. He held many township positions, including justice of the peace. A man of intelligence, he tried to improve the business of agriculture, inventing the Colgrove potato digger. This invention picked potatoes and cleaned them of weeds when it brought them to the surface. After the digger was patented, he had it manufactured at the Allen brothers' Granite City Iron Works in St. Cloud, of which he became secretary. James was a Mason in Clearwater and served as master many times. He married Mary Stearns. The couple had three children.

George E. Warner of Lynden Township was born in Quebec in 1826. A farmer from birth and involved in lumbering, he learned the blacksmith trade. He arrived in 1857 in Minnesota, where he farmed for over 40 years and made his home and farm by the picturesque Warner Lake, named after him. Always interested in the affairs of Clearwater, Lynden Township, and St. Cloud, Warner was an active member of the Old Settlers' Association. He was on the Lynden Township Board of Supervisors, serving as chairman for two years. He became justice of peace, was appointed to a position on the Stearns County Council Patrons of Husbandry in 1875, and was on the rural school board. He was also a member of the Masons in Clearwater. Warner married Sarah Wilcox from Quebec in 1848. The couple had two children.

Warner Lake is one of more than 10,000 lakes of Minnesota and also one of over 200 in Stearns County. Plum Creek winds its way in and out of the county toward the Mississippi River. The area is covered with woodlands, marshes, and wild berry bushes. Prime for fishing, the waters offer the angler crappies, sunfish, and pike. In the summer, the periphery is a fringe of white, yellow, and green as lily pads float by the shoreline.

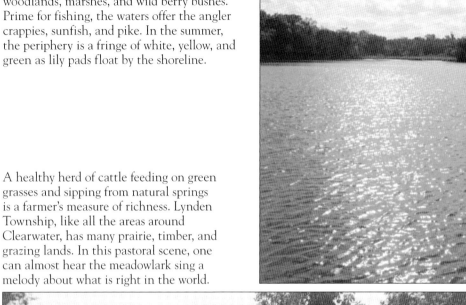

A healthy herd of cattle feeding on green grasses and sipping from natural springs is a farmer's measure of richness. Lynden Township, like all the areas around Clearwater, has many prairie, timber, and grazing lands. In this pastoral scene, one can almost hear the meadowlark sing a melody about what is right in the world.

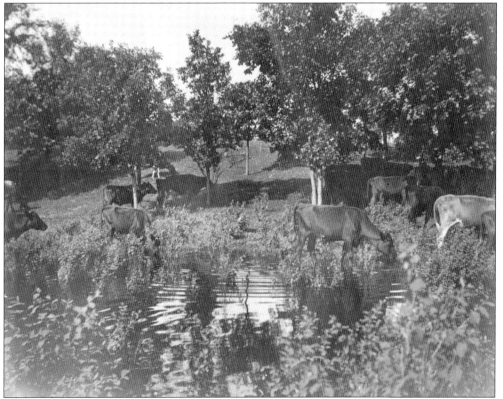

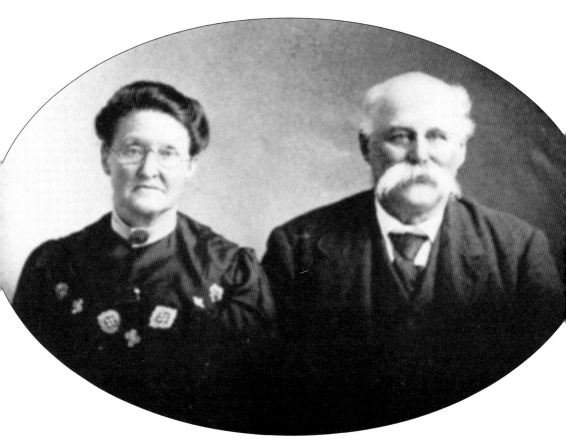

Daniel D. Miller was one of the early pioneers in Lynden Township. Born in 1843 in Ohio, he arrived in 1867, buying up an existing homestead. He cleared the land, bringing it into cultivation. Soon, Miller realized that part of his property was resting on limestone. He built a kiln and began burning lime as well as farming. He remained active in the township, sitting on many boards, including the Lynden School Board. Miller married Harriet Dawson in 1867. The couple had 10 children. Son Clarence married Jennie Heaton, daughter of Lynden settlers Homer and Ida Slattery Heaton. Clarence acquired the homestead upon his parents' deaths, and with his neighboring 80 acres, he developed and improved his land into one of the best 160-acre farms in the area. Clarence raised a herd of full-blooded cattle and a drove of swine.

The son of Luke Stokes, born in England in 1820, and Mary Weilding, born in England in 1822, George Stokes came to Stearns County in 1866 when he was 16. After living in New York City, the family took up farming in Lynden Township. Luke learned pioneer farming, and soon after settling in the area with his family, he bought 80 acres of his own. Over time, he purchased over 200 acres, and along with raising stock and cultivating and harvesting the fields, he built up the farm. Luke married Eliza Beilstein Carlile. The couple had four children and were members of the Clearwater Methodist Church. His brother Sam purchased their parents' homestead, updated the buildings, and applied up-to-date agricultural methods to the farmland, producing crops with state-of-the-art equipment. Sam married Carrie Miller, daughter of Daniel and Harriet Miller.

A son of Benjamin T. and Lydia Lyons, William Lyons, pictured on the left, was born in 1840 in Ohio. Both parents were born in Virginia, his father on a plantation in 1814. Benjamin came to Lynden Township with them in 1856. After his father secured 160 acres, Benjamin helped the family get established before enlisting in Company D, Minnesota Mounted Rangers, in 1862 to fight in the Civil War. He fought in the northwest against the Sioux, and by 1863, he was honorably discharged due to a disability. He returned home and purchased his own farm before marrying Susannah Mitchell in 1882. In 1885, the couple endured a heavy fire, losing their house and many outbuildings. They built again and increased their farmstead, known as Lakeside Stock and Grain Farm, to 193 acres. The Lyons were members of the Clearwater Methodist Episcopal Church. Pictured on the right are, clockwise from left, William's wife, Susan Mitchell Lyons, and daughters Lydia Lyons Collins and Jane Lyons Ostrander.

James Lyons, another son of Benjamin and Lydia Lyons, was born in Ohio in 1846. He helped on the family farm until 1864 when he, like his brother William, went off to fight in the Civil War. He enlisted in Company E, 8th Minnesota Volunteer Infantry. After discharge in 1865, James returned home and worked at farming and logging. He eventually purchased 160 acres. In 1878, he married Mary Ridley from Silver Creek. Eventually, they moved to Clearwater and opened a confectionery where they sold canned goods, ice cream, candy, and cigars and operated a lunchroom and restaurant. James was the village marshal and was the senior vice commander for the A.C. Collins Post 112, GAR of Clearwater.

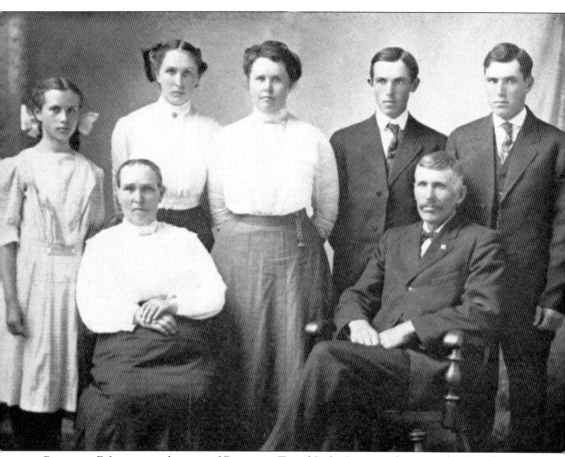

Benjamin F. Lyons, another son of Benjamin T. and Lydia Lyons and owner of Oak Side Stock and Grain, was born in Ohio in 1856, before his parents moved to Minnesota. He attended school in the township. D.D. Storms, one of leading teachers in Stearns County, was his instructor for a number of years. When Benjamin F. turned of age, his father gifted him nearly 100 acres to start his own farm. He developed his farming and dairying business into one of the most revered in the township. Benjamin married Ann Mitchell in 1879. Benjamin belonged to the Old Settlers' Association, was a member of the township board, and was an official for the Methodist Episcopal church in Clearwater. He and Ann had six children. He and his wife are buried in Acacia Cemetery in Clearwater.

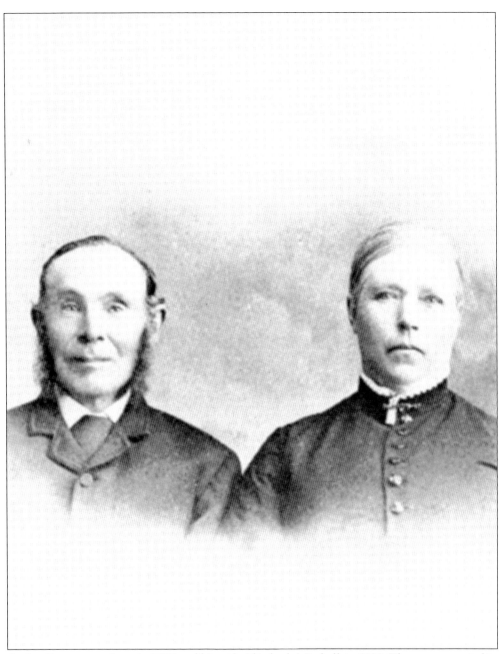

Arthur Stewart was born in 1830 and his wife, Elizabeth Mitchell, in 1832. They were married in 1854 and emigrated from Ireland in 1880. They located in Lynden Township near other Mitchells, purchased 160 acres, and started farming. They built up their farm and constructed a modern home and outbuildings but turned over the ownership to their son William in 1894. Arthur and Elizabeth had six children. One son, Alexander, moved to England, and two other sons, James and George, moved to Australia. William married Elizabeth Eickmeyer. The Stewarts belonged to the Clearwater Methodist Episcopal Church. Arthur died in 1904. Elizabeth died in 1908. Their funerals were at the Methodist church. Both Arthur and Elizabeth are buried in the Acacia Cemetery in Lynden Township.

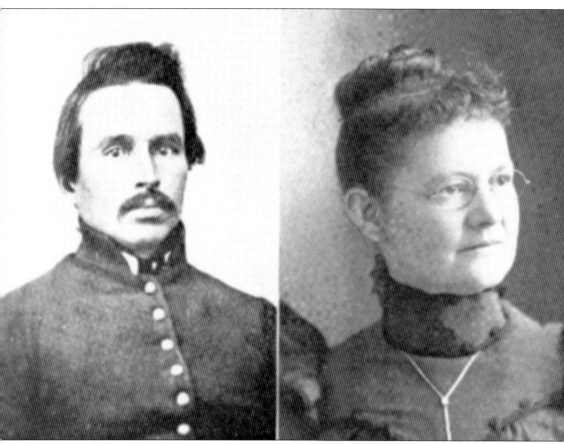

Wilbur Fisk, born in Vermont in 1830, came to the Clearwater area in 1857, settling in Lynden Township. In 1865, he enlisted in Company E, 1st Minnesota Heavy Artillery, assigned to garrison duty in Nashville, Tennessee. After he was mustered out, he married Sarah Townsend in 1867. She was born in 1847 in Pennsylvania. The Fisks belonged to the Old Settlers' Association, and Wilbur was a member of Charles Gibbs Post 11, GAR. Sarah and other Townsends were scandalized when her uncle John Townsend married Jane Hallett. Townsend's farmhand, William Dunham, began to harass Jane, smearing her reputation by bragging that they had had an affair. When John Townsend heard, he kicked Jane out of the house. She took an ax to Dunham, killing him. In 1879, she was sent to the state hospital for the insane.

When Alexander Mitchell, pictured at right, was eight and his younger brother John was four, they came with their mother Elizabeth Mitchell and siblings from Ireland to reunite with their father in Minnesota. William Mitchell had arrived in New York in 1865 and enlisted in the Civil War. When he was mustered out, he bought land south of Lynden Township. After proving up, he bought 80 acres in Lynden Township. William died in 1872. Alexander and John, along with their mother and siblings old enough to work, helped build up the farm. When the two were of age, they bought additional land, incorporating it into the Lake Maria Stock and Grain Farm. Pictured below are John Mitchell and his wife, Mary Ross Mitchell, who worked in the St. Cloud school for a number of years. John was township supervisor and, for a while, president of the First State Bank in Clearwater.

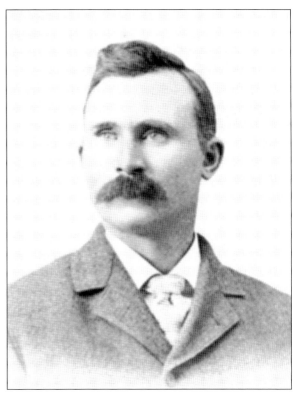

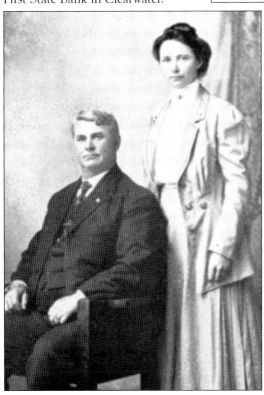

Mary Ponsford Dorsey, daughter of Joseph and Sarah Vaur Ponsford, was born in England in 1851, immigrated to the United States in 1854, and came to Minnesota in 1860. Her parents took a claim located in both Clearwater and Lynden Townships. In 1870, she married Orrin Dorsey of Lynden Township. The couple had one daughter, Ida, born in 1871. Here, Mary is picking wildflowers by the Tamarack Swamp.

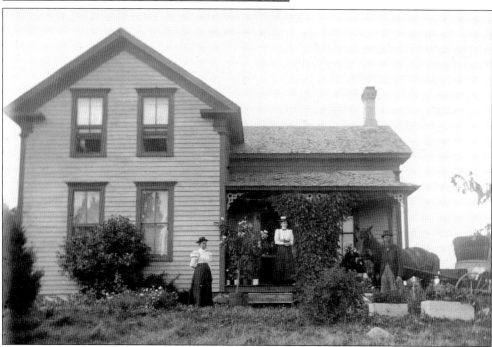

Orrin and Mary Dorsey's home and farm was called Rose Hill Place. Orrin was an early homesteader. He helped build the first hotel in Clearwater, the Oyster House, which stood by the mouth of the Clearwater River. Daughter Ida stands on the porch with her mother, Mary. Orrin stands by the horse. The photographer was Charles Ponsford.

Charles Ponsford took this picture in the Dorseys' house. The musicians are Will Fisher on the mandolin and Cora Fisher on the guitar. They are Orrin Dorsey's nephew and niece, his only sister Celestia's children from Illinois. They stayed in the Lynden area for a year working for their uncle. Their father, Greenberry Fisher, was a house painter and a paper hanger in Basco, Illinois.

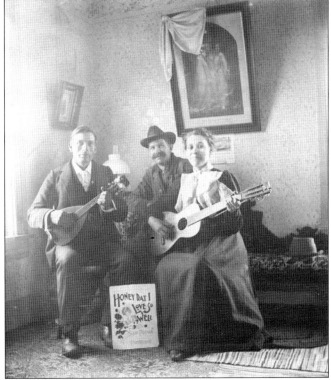

Here is another of Charles Ponsford's pictures of the Fishers. Will is on the mandolin and sister Cora is on the guitar. The sheet music is for "Honey Dat I Loves So Well," composed by Harry Freeman. When Will went back to Illinois, he became a brick manufacturer. He married Laura Forster. The couple had four children. Cora married Clyde Roath in 1923. They had no children.

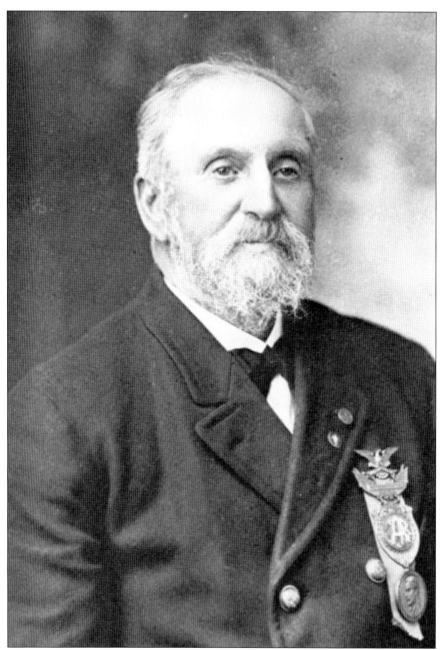

David Duane "D.D." Storms, one of the most influential farmers and teachers in Minnesota, started his life in New York. The son of John and Elizabeth Dady Storms, D.D. was born in 1839. With a good education, he taught school in winter months and farmed in the summer in New York. When the Civil War broke out, he enlisted in the 25th Illinois Volunteer Infantry. After he returned to civilian life, he followed his uncle Rev. William Dady, who had located in Clearwater. D.D. purchased 160 acres in Lynden for $700, homesteaded on 80, and bought more from the railroad. He continued teaching, becoming an integral agriculturist in Minnesota. He married Mary Ann Ketcham, who was born in New York in 1840. They had one son, Frank. D.D. taught at Standing Rock Indian Reservation as an industrial teacher.

Five

"THE HUB OF THE UNIVERSE"

Insurance agent William Pineo toasted Clearwater at one of the annual Old Settlers' Days. He called the village "The Hub of the Universe," because without its farmers, storekeepers, railroad personnel, educators, doctors, and clergymen, the world could not get along.

James Colgrove and the Granite City Iron Works in St. Cloud produced the potato digger that saved farmers time and sweat all over the United States. He and others, like D.D. Storms, both teachers and farmers, taught many about new agricultural methods that would be more efficient and productive and help feed the world.

Men like William Shaw and Dave & Beal bought farmers' grain, which they ground into flour at their mills and then sold to bigger markets in Minneapolis. Luther Laughton and Gilbert Winslow butchered the livestock that farmers sold. General merchants Sam Whiting, William Webster, Robert Lyons, and A.M. Maxam bought and dispensed the everyday goods to keep a community running. George Boutwell supplied the paint, nails, and tools from his hardware store to build a village, while carpenters like Henry Morrison and Sam Marvin built the stores and houses of the people who lived here. Deke Collins and Thomas Biggerstaff, just two of the many blacksmiths, kept the wagon wheels turning to get every job done.

The railroad could not run without the management of William Peck, agent George Newell, and foreman Carl Phillips, who made sure the trains ran on time and the tracks were free of debris and livestock.

Drs. Jared Wheelock, Ira Edmunds, Gilbert Tollington, and Ernest Kingsbury and druggists Phillip Schwab and Stanley and Jennie Phillips worked to keep the community healthy. For spiritual health, the village looked to ministers like Reverends Gleason, Stevens, and Barkuloo to keep their souls safe.

Clearwater provided the universe with some of the best teachers as well. Pitt Colgrove taught future teachers at the St. Cloud Normal School before becoming superintendent of schools in Virginia, Minnesota. Grace and Sarah Whiting, Harriett Dunton, Jeanette Sanborn, and Charles Stevens, son of Simon Stevens, dedicated their lives to educating the youth.

Livestock, grain prices, and world news were delivered by loyal newsmen such as John Evans and Bert Whiting. Stanley and Jennie Phillips had the federal contract for the post office, but it was Sherm Shattuck who delivered the mail to people around Clearwater from others who considered themselves once part of this community.

"Could this universe get along without Clearwater people?" Pineo asked. "No, indeed!"

These young adults represent the future of Clearwater. They will enjoy the fruits of their parents' labors and carry on where that generation left off. Although the identity of many is lost in obscurity, some faces are familiar to Clearwaterites. Nettie Brannan Kniss was the mother of grocer Eliss Kniss. Maud Porter, the daughter of Thomas and Abigail Porter, had the reputation for being the oldest living female in Clearwater and an active member in many local groups, including the Woman's Christian Temperance Union. Ella Boutwell was the daughter of hardware store owners George and Anna Boutwell. She married Frank Kothmann, pictured to the right, with his hand on Ruth Phillips's shoulder. In her unpublished narrative, *Memories of Clearwater, 1890–1910*, Ruth writes about cutting her hair Her sister Jennie became the town pharmacist.

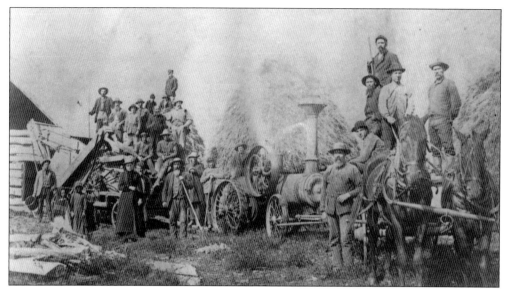

These pictures could have been taken anywhere but are likely from Clearwater or Lynden Township. A team of about 20 men worked on a threshing crew helping farmers around the country separate grain from straw. This was a community effort of neighbors—men, children, and women—who worked long hours at the end of summer to get their wheat or oats ready for market. Farmers took turns helping other farmers. Children ran for water or snacks. Mostly unseen workers, women took turns at one neighbor's home, helping cook and serve the food before moving on to the next neighbor's. They cooked huge meals including pork chops or fried chicken and mashed potatoes, corn or beans from the garden, and chocolate cakes and rhubarb pies. They fed workers midmorning and afternoon snacks. Everything was homemade and grown on their farms.

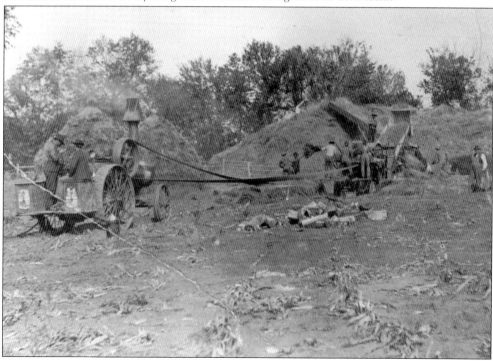

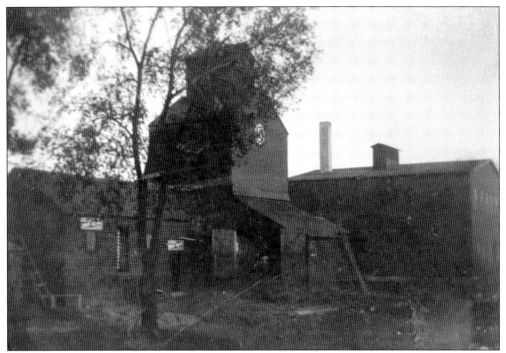

Elevators held an important role in rural communities, Clearwater as well. This edifice near the train tracks allowed for easy access to load and unload, sending wheat or other grain to larger markets like Pillsbury or General Mills in the Twin Cities area. A *Clearwater Herald* notice states that on April 30, 1904, C.B. Whitney turned over his business to A. Rasmusson, who bought his "stock of flour and feed."

The Great Northern Flyer stopped in Clearwater on its way from St. Paul to Seattle. Known for its reputation as a fast mail carrier, this train brought people in and out of the village as early as the late 1890s, later being replaced by the Great Northern Limited and later the Empire Builder, linking Chicago to Seattle. Passengers depended on James Hill's trains to get them where they wanted to go.

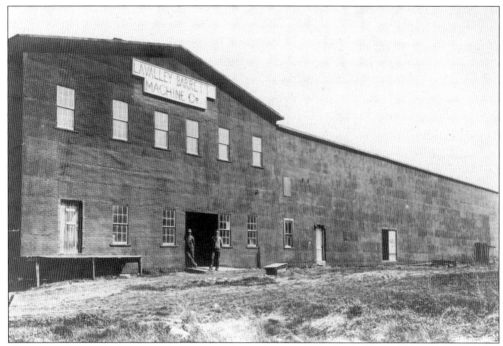

Clearwater boasted of having the most machine shops in Wright County. This one, co-owned by Lynden Township families the LaValleys and the Barretts, sat by the train tracks south of the depot and was once a canning factory. At the beginning of the 20th century, the shop workers built and rebuilt wagons, carriages, farm equipment, and anything else mechanized.

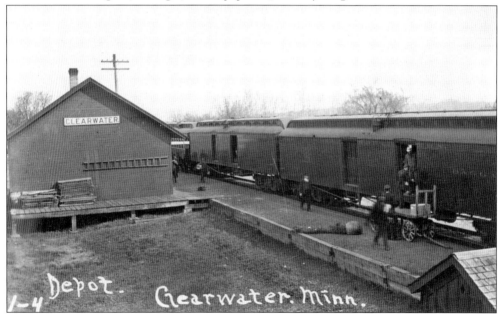

The train depot, the hub of the village, was managed by William Peck, John Harrington Steven's son-in-law, and was operated by agent George Newell and yard foreman Carl Phillips. Here, cars were filled with grain, mail, livestock, supplies for stores, and people. For years, the depot housed the only telegraph to get news in and out of the community. It was always abuzz with activity.

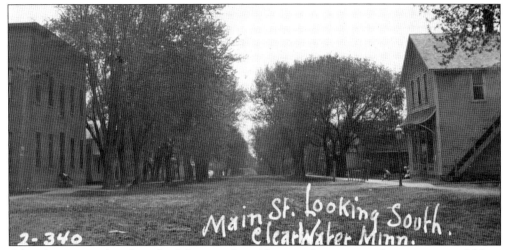

After the train replaced much of the steamboats' business bringing goods upriver, central Main Street became more of a hub because of its juxtaposition to the depot. In the mid-1890s, Stanley Phillips moved from Oak Street to Main Street. This picture shows the drugstore on the right, Barrett's Livery next to it, and the Leme or Clearwater Hotel on the left.

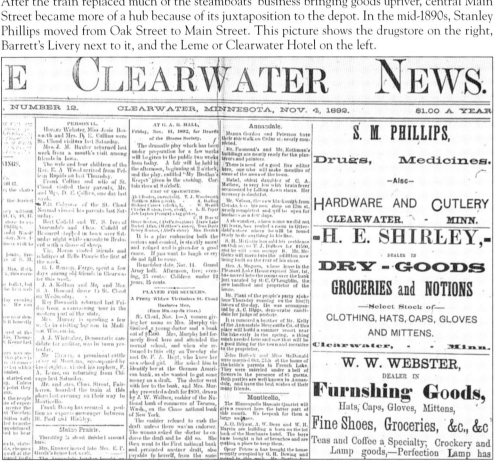

S.M. Phillips sold a number of items in his drugstore besides patent medicines and prescriptions written up by a doctor. Paint, hardware, and cutlery were necessary items if the hardware store was not open. Hattie Shirley took over the management of the dry goods store when her husband died. She also traded eggs, butter, and cream for purchases in the store.

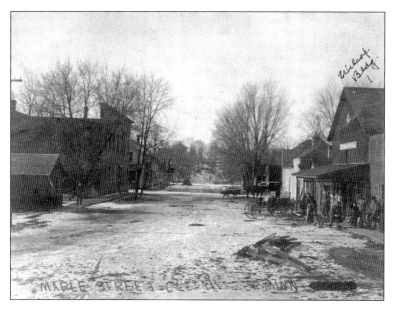

So much activity is taking place in this east-west Maple Street view. Phillips Drug Store is peeking over the shoulder of the Leme Hotel. The harness shop is on the right. Lots of men are waiting for a job to be done. Next to it is the Wilcox building with the Lyon's store in front. Way on top of the hill stands the school.

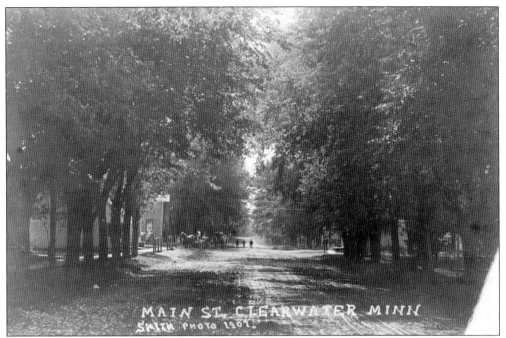

This gives an excellent southern view of Main Street's trees. Some areas were so thick at times that the trees formed arches for people, carriages, and later cars to travel under. Leme's Hotel is on the left with two carriages parked in front. A woman sits in the one on the side in front of the window that reads "Hotel," and three people stand in the middle of the street.

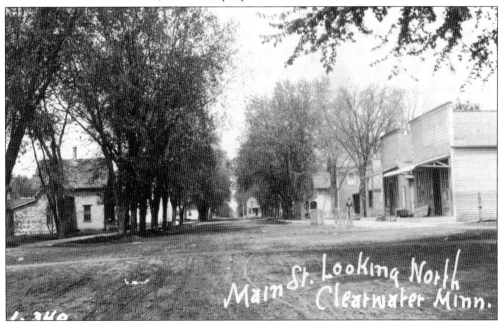

Robert Lyon's General Store is the first false-front building on the right. The second false front belongs to Laughton's Meat Market (which at one time was H.L. Barrett's butcher shop). Next is the First State Bank owned and operated by Joseph Whittemore. Luther Laughton's house stands next to the bank. Across the street is the Rigby home.

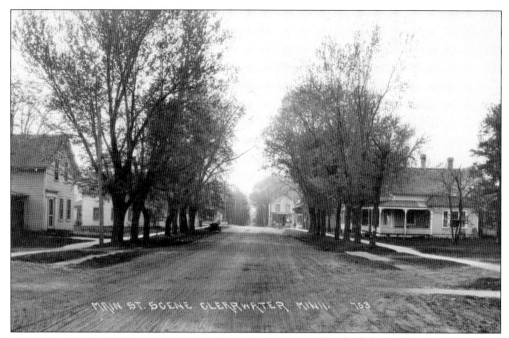

On the left is the Fish home. On the right porch is Maud Porter's last home, with the wraparound. Maud lived to be 103. At the end of the block, the Whiting Building is barely visible, and facing south, Boutwell's Hardware keeps an eye on Main Street. An article in a May 1902 *Clearwater Herald* states that Maud Porter's house had a fresh coat of paint.

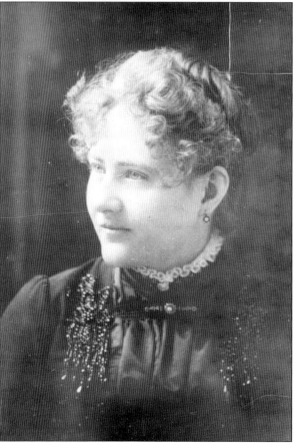

Born in 1862, Jessie Maud Porter lived her entire life in Clearwater. Her father, Thomas, and mother, Abigail Robinson Camp Porter, pioneered in the village. Maud, as everyone knew her, was the longest-lived Wright County citizen, dying in 1965 at the age of 103.

Anna Kubat was born in Austria in 1841 and emigrated around 1852. In 1865, she married George Boutwell, who was born in 1843 in New York. He fought at the First and Second Battles of Bull Run and the Battle of Fredericksburg, and he served time in three Southern prisons. The couple moved to Clearwater in the 1870s. George started Boutwell's Hardware Store and was elected twice to the Minnesota Legislature. The couple had five children. (Courtesy of Kitty Johansen.)

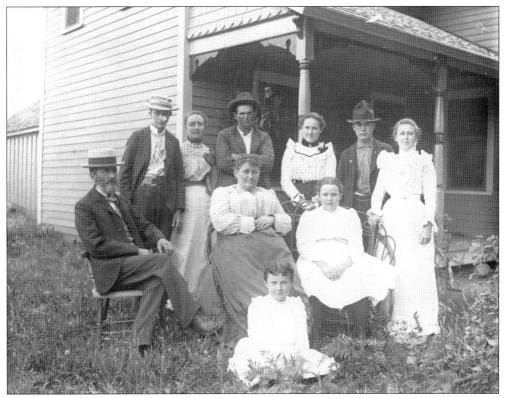

Stanley and Maryetta Crossman Phillips lived on Main Street, a block from the family-owned-and-operated Phillips Drug Store. Shown here, from left to right are (back row) Percy, Jennie, Carl, Blanche, Sam, and Agnes; (middle row) Stanley, Maryetta, and Harriet; (in front) Ruth. When Stanley died in 1903, Jennie took over the business. The youngest, Ruth, wrote a detailed, but non-published, book about her family's experiences, *Memories of Clearwater, 1890–1910.*

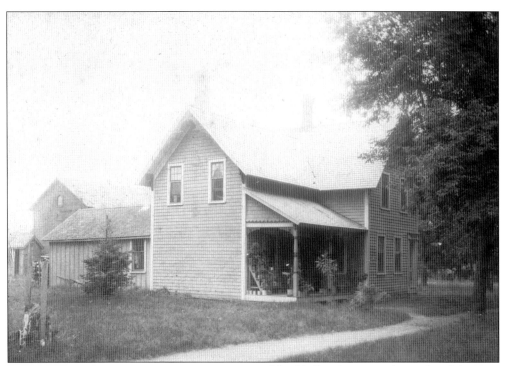

The Phillips home was located on Main Street. Here, Stanley and Maryetta raised their 10 children, two dying when they were young. When the parents died, and most of the children had left the house to work or marry, Jennie and Agnes maintained the home. Jennie took over Phillips Drug Store with Agnes's help.

Born in Maine in 1852, Maryetta Crossman came to Minnesota with her parents and worked as a domestic for Jed Fuller before marrying Stanley Phillips. In her narrative, daughter Ruth writes that she was a loving mother of easy temperament and, like her daughters, a "bit fleshy" because everyone loved to eat Maryetta's cooking.

Jennie Phillips was the eldest child of Maryetta and Stanley Phillips. Trained to teach at the St. Cloud Normal School, she took up her first position in Atwater, Minnesota. Her parents asked her to help in the drugstore one year later, in 1894. She did and became a certified pharmacist. After her father died, Jennie became the solo pharmacist, but her siblings often helped in the store.

Teenagers are skating on the man-made ice rink in town. The elevator, water tank, and windmill are visible in the background. The girls wear shorter skirts, so maybe this picture was taken in the early 1920s. One of the boys has fallen down, but they are all posing for this picture and seem to be having a good time.

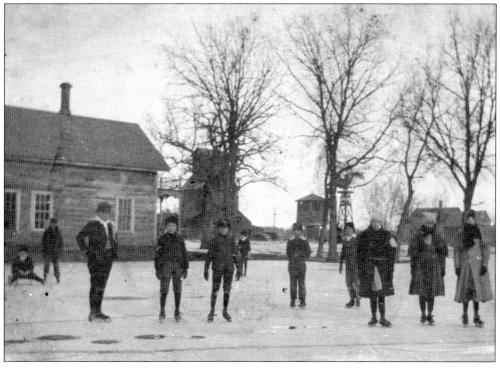

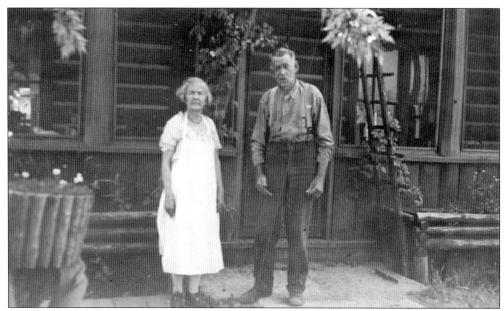

Minnie Phillips, sister of Stanley Phillips, was born in 1842 in New York. She married Elmer Baxter, and they came to Clearwater in 1868, living almost their whole lives in the village. In 1912, she and her husband spent a year in Montana, where this picture was taken.

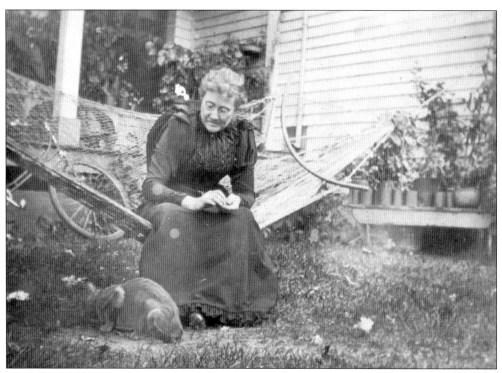

Maud Porter sits in her hammock and feeds her cat. Leaning against the porch is the bike she purchased after her visit to the Chicago World's Fair in 1893. Maud was a trendsetter; soon, many in the area road bikes. There was nothing to harness and it was faster than a horse for a short ride.

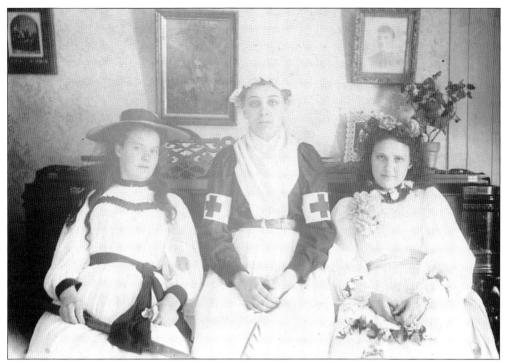

Nettie Brannan, in the middle, and Ruth Phillips, on the right, pose in the Phillips home. Nettie was involved with the Red Cross in Clearwater from its early years. The girls may have been helping with a fundraiser by putting on a play. Red Cross women sent money to the national society and gave to local needs, such as when the Auwaters' son died during World War II.

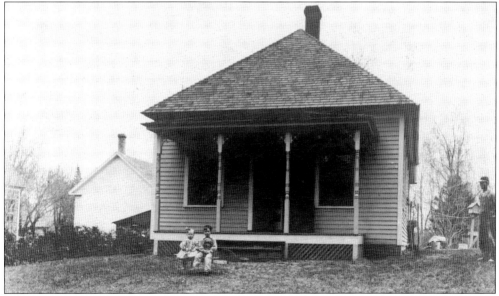

This is the Kniss home on Spring Street. Nettie Brannan married Eliss Kniss Sr. sometime before 1903. The couple had three daughters, who continued to live in the house after son Ellis married. This picture shows Ellis and his sister Viola sitting in a wheelbarrow. Ellis was born in 1902. He owned Kniss's Grocery Store in town.

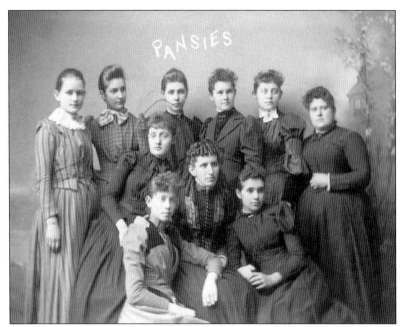

Jennie Phillips attended the St. Cloud Normal School, graduating in 1893 with a teaching degree. Here, she is at left in the second row, somewhat leaning in. She is with a group of college friends or a sorority group. Someone scratched in "Pansies" at the top of the picture.

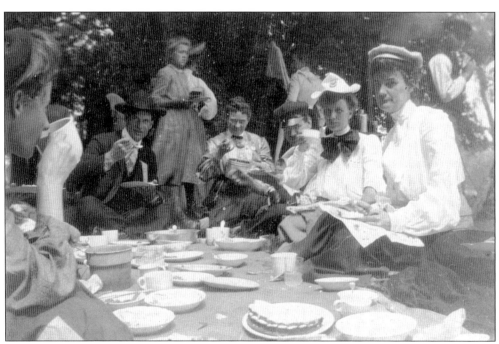

A number of Clearwater women went to Virginia and Eveleth, Minnesota, on a tour of the iron ore range sometime around 1910. Iron ore was an important product in the United States and Minnesota especially, for the state was the leading producer in the world. Here, the women are enjoying a picnic together.

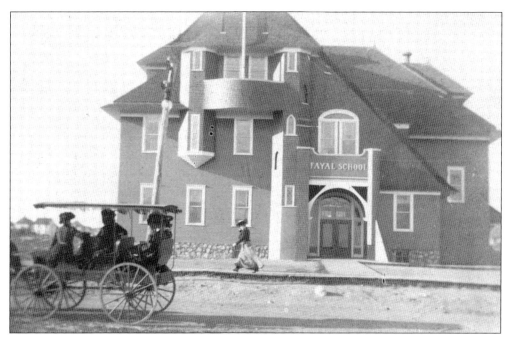

This picture is of the Fayal School in Eveleth, sometime before it burned down in 1910. The iron ore business paid for some elaborate schools at times. This one was an example of what the mining dollars could buy.

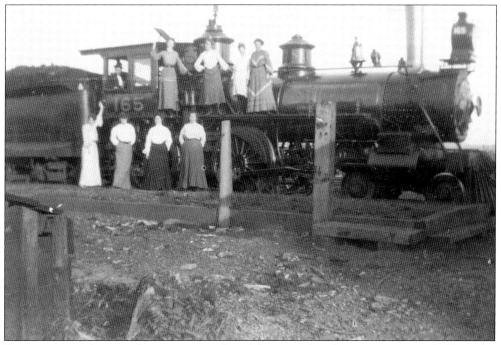

From iron ore to logging, the trains in northern Minnesota kept busy exporting goods. Here, the Clearwater women have boarded the train in an unusual fashion, without suitcases or parasols. The local engine had stopped in Virginia, Minnesota. Apparently, when the conductor hollered "All Aboard!" the women wanted to have some fun.

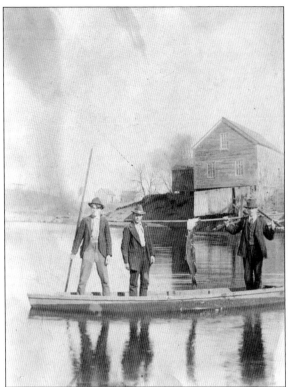

The Clearwater and Mississippi Rivers offered some of the best fishing, and they lured many before, during, or after work to their waters to catch the big one. This picture, with three men dressed in suits and ties, is from before 1897, because the mill in the background, standing on the shore of the Clearwater River, was washed away during a flood that year.

Sherman Shattuck, who was born in 1865, came to Minnesota from New York with his parents, Curtis and Amanda Shattuck. He married Ida Dorsey in 1892. Sherm farmed in Lynden Township, and for many years, he worked as a clerk and rural mail carrier in Clearwater. Here, he is in his horse-drawn carriage. He also had an early motorcycle and, finally, a car. All were used to deliver the mail.

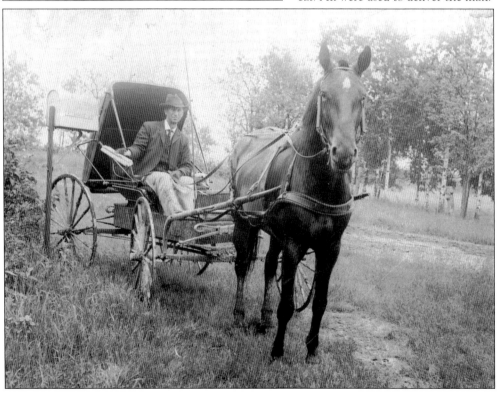

Ella Boutwell (pictured) was born in Kansas in 1879 to George and Anna Boutwell. She married Frank Kothmann around 1905. The couple farmed south of town and had one son, George Everett, who was born in 1907. After Ella died in 1947, Frank married Ella's widowed sister Josephine Satterrlee. All are buried in Acacia Cemetery.

The Clearwater River's course changed many times because of the water flow either from flooding or from milling, but the magic of the millpond pulled many to its shores for fishing and swimming. Ruth Phillips Sheldon writes about it in her narrative, and generations later, people remember the pond's charm. Many youth learned how to swim in these waters, thanks to the Red Cross.

One can only imagine the excitement and nervousness Ebba Pearson must have felt as she hollered good-bye from her train window to family and friends below at the Clearwater Depot. After she arrived in Minneapolis, Pearson became a career girl, beginning her sewing job at Munsingwear Manufacturing. (Courtesy of the Sheldon-Tesmer families.)

Levi Sheldon (right), son of George and Mary Sheldon, and his unidentified friend pose here wearing straw hats at rakish angles. Men's fashion changed at the turn of the century, just like women's. Levi farmed in Clearwater Township all his life and lived next door to Ebba Pearson. Sometime around 1919, the couple married. They had two children, Joyce and Howard. (Courtesy of the Sheldon-Tesmer families.)

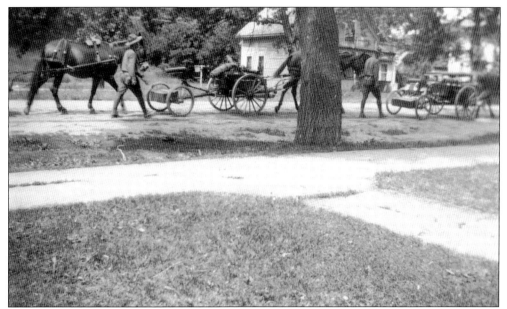

Clearwater, like many communities across the nation, welcomed soldiers back home after World War I. Part of the celebration would have included a parade. Here, the veterans walk in a parade down Main Street. This picture was taken around 1919 and from the east, probably near the Phillips home. The Collins-Sanborn home is across the street to the left, and the Shaw house is farther down the street.

Loyal Sheldon poses with his mother, Mary, and father, George, around the time of his enlistment in World War I. On his registration card in 1917, he declares that he is single and farming in Hackensack, Cass County. Loyal Sheldon came home and married Josie Kathleen Hall from Illinois. Everyone in town knew her as Kath Sheldon. They lived on Main Street. (Courtesy of the Sheldon-Tesmer families.)

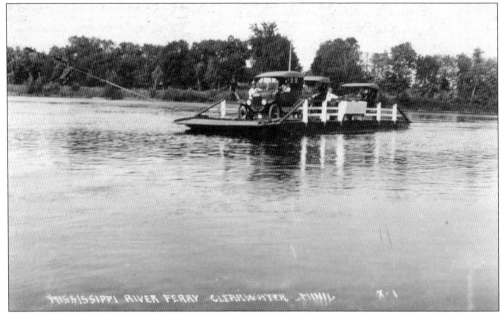

These three autos on the ferry date around the 1920s. The Kirks still ran this mode of transportation until the early 1930s, when the bridge went in. Along with horse-pulled wagons and buggies, autos were transported, as well as livestock to be sent on the railroad to slaughterhouses and stockyards.

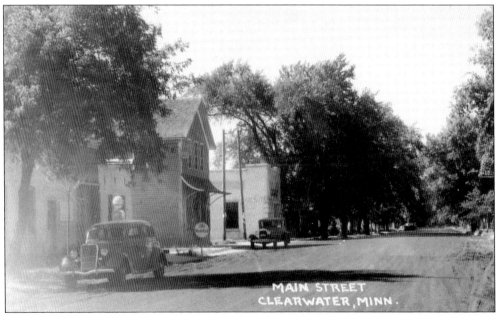

Up front, two cars are sitting on Main Street, one by Phillips Drug Store, more than likely Sherm Shattuck's 1926 Buick, which he used for mail delivery. The other is a mid-1930s model that sits in front of the garage, which used to be Barrett's and Rice's Livery. Customers could get oil changes and fill up on Mobil gas. A couple of cars are parked in front of the Methodist Episcopal church.

Six

ANCHORS

It takes more than buildings, farming interests, and businesses to build a village. Soon, many pioneers realized they needed to grow spiritually, socially, and intellectually. Although the first Methodist service was conducted in 1855 a few miles from the village townsite, in 1858, Rev. Levi Gleason conducted the first sermons at the Fremont City schoolhouse and the village schoolhouse Frank Morrison owned.

Because of grasshopper plagues and poor crops, years went by before the Methodist congregation prospered enough to build a church. In 1881, Simon H. Marvin constructed the simple white building on Main Street, an example of Greek Revival architecture. This building has been remodeled a number of times and has been in constant use since its beginning.

The Congregationalists erected their church sooner. Frank Morrison donated the lot on top of the bluff overlooking the town. A white edifice and another example of New England's Greek Revival architecture, this church served the community from 1861. Shortly after its opening, it was fortified so families in the country could find haven during the Sioux Uprising. Even though it is in the National Register of Historic Places, it is no longer in use.

The Church of St. Luke, Clearwater's Catholic church, has been located in three places. Rev. William H. Blum, from Fletcher, Minnesota, conducted the first Catholic services to a small congregation. Later, Annandale, Minnesota's St. Ignatius, under the guidance of Rev. Charles Cavanaugh, helped organize the village parishioners. They purchased the first schoolhouse on the corner of Ash and Lime Streets for services. The second church, built of brick in 1904, stood on the corner of Spring and Maple Streets. The newest church is located west of Interstate 94 on Huber Avenue.

Clearwater also hosted a number of civic and religious organizations, such as the Masons, Eastern Star, Rebekahs, Modern Woodsmen, GAR, Women's Christian Temperance Society, Epworth, Methodist Youth Fellowship (MYF), Christian Endeavor, and other classes for its younger citizens. Over the years, the village had a number of bands.

Early founders envisioned an educated and intellectual village to continue what they had started. The first school was taught by A.C. Powers in an unused store. Later, a school was built on the bluff overlooking the village. It was remodeled, accommodating the addition of a high school, and eventually, in the 1960s, it consolidated with the St. Cloud School District.

As 19th-century education reformer Horace Mann once said, "A human being is not attaining his full heights until he is educated." Obviously, Clearwater citizens felt the same way.

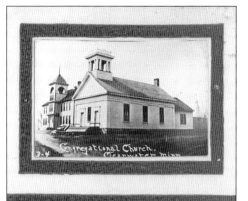

In 1859, the First Congregational Church was organized by a handful of people. Frank Morrison donated land for building the church. An example of Greek Revival architecture, it was fortified with a stockade for those in the country seeking refuge during the Sioux Uprising. Oral history claims that a tunnel was dug underneath the church for easy escape to the Mississippi. No evidence has been found for this, and no attack came.

Old Friend, I dream again, the skies are blue The sound of rippling rivers fill my ears, And borne upon the current of past years, My thoughts are drifting back again to you.

Listed in the National Register of Historic Places, the small Congregational church on Bluff Street keeps watch over the whole village. Membership interest began as early as 1859. Luther Laughton laid the posts for the foundation, William Webster donated the wood, and the building began. In 1861, Rev. A.K. Packard from Anoka dedicated the church. Although it is still standing, the church is no longer in use.

Although services for the Methodist Episcopal Church were conducted as early as 1858 by Rev. Levi Gleason at the Fremont City schoolhouse near the Clearwater River, the church on Main Street was not constructed until 1881. An appointed trustee of the church, S.M. Marvin, the area's first documented carpenter, wanted the building to resemble those left behind by the New Englanders who settled the community.

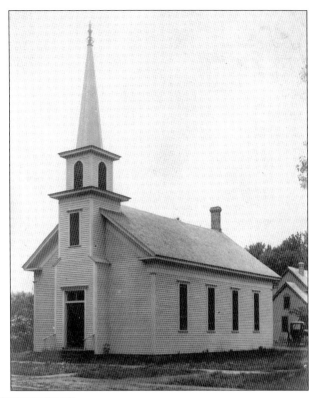

Hazel Metcalf, a longtime villager, sits here in the Clearwater United Methodist Church pew that she shared with her sister Ruby Metcalf. The pews were the handiwork of Simon "Sam" Marvin, who built the church and as superintendent presided over the church council until his death. They are still in use, with new coats of paint.

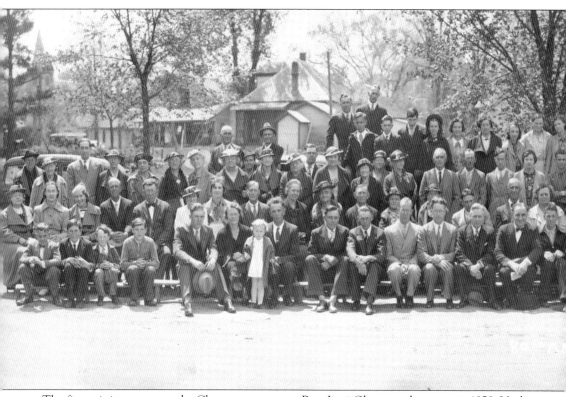

The first minister to serve the Clearwater area was Rev. Levi Gleason, who came in 1858. Under the supervision of Rev. Leland Smith, the Methodist congregation of the early 1880s paid off its debts and erected its white church. Pictured here are families related to the earliest members: Lyons, Sheldons, Biggerstaffs, Mitchells, Stewarts, Stokes, and Porters. In the 1940s, the edifice was moved to the street so workers could build a basement. The building has been remodeled a few times, but

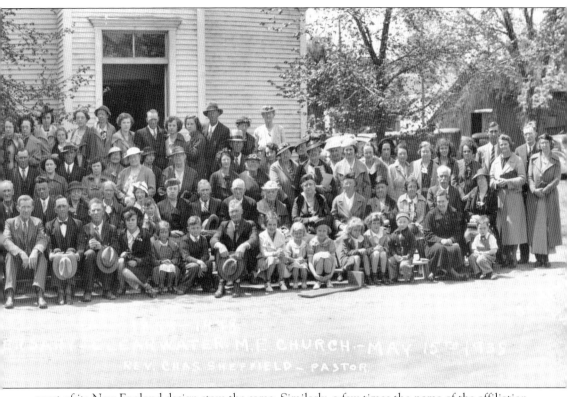

most of its New England design stays the same. Similarly, a few times the name of the affiliation has changed—from Methodist to Methodist Episcopal to United Methodist—but most who attend here call themselves Methodists. A few other ministers who have served Clearwater include C.T. Barkuloo, Noah Lathrop, Charles Sheffield, Swan Mattson, Gerald Domonoski, Mary MacNicholl, Peter Fribley, and Kenneth Felska. (Courtesy of Clearwater United Methodist Church.)

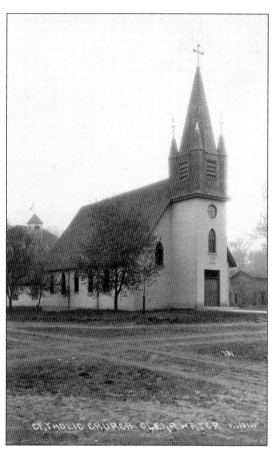

Under the direction of Fr. Charles Cavanaugh of St. Ignatius Catholic Church in Annandale, the Church of St. Luke relocated on Spring Street, and according to *Clearwater Herald* publisher John Evans's April 30, 1904, column, "plans for the new Catholic church have been received. The church proper will be 30x70 . . . and the contract for the building will shortly be let."

Pictured outside of the Church of St. Luke in the spring of 1945, these girls are dressed up in white after the sacrament of First Communion. Identified holding candles are, in no particular order, Maggie Jueneman, Cecilia Ablen, Vonnie Totz, Sally Flynn, Connie Killeen, and Mert Mooney. Not pictured are the boys: Collin Langanki, Butch Helget, Doc Gohman, and Raymond Iten. (Courtesy of Sally Flynn.)

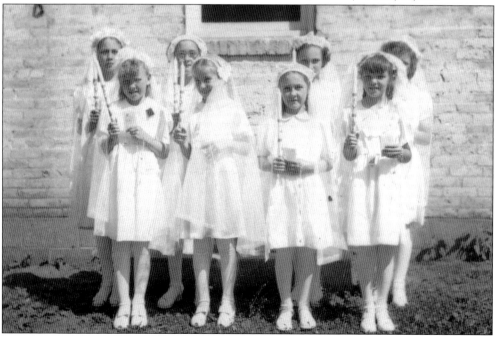

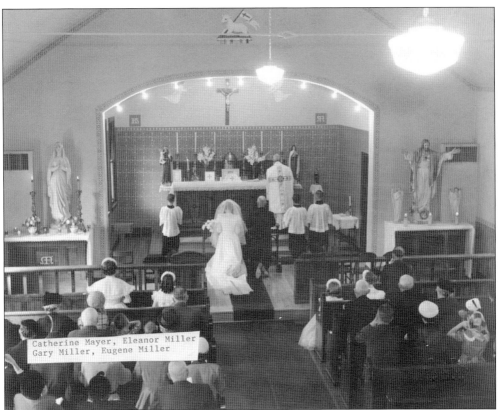

Catherine Mayer, Eleanor Miller
Gary Miller, Eugene Miller

Pictured above, Fr. John Kral married Luverne Mayer and James Mooney in the Church of St. Luke in 1952. Those attending the couple were Mildred Ege, Malacky Mooney, Elaine Miller, Kathryn Mayer, Maureen Scanlon, James Flaherty, and William Wilberding. At right, Fr. Donald Salt married Carol Allen and Ronald Freeman in 1969. Attendants were Linda Ergen, Cindy Frank, Virginia Freeman, Kevin Kronquist, Dale Homuth, and Mike Allen. After Vatican II, the interior changed. It was remodeled in 1963 under the guidance of Fr. Clarence Zlotkowski, with new light fixtures, electric baseboard heat, oak-colored pews, and an updated altar. A stained-glass window was placed above the front doors. Most noticeable is how the priests officiated at the services due to Vatican II. Father Kral has his back turned, and Father Salt faces the congregation. (Above, courtesy of Elaine Paumen; right, courtesy of Elaine Paumen and Carol Freeman.)

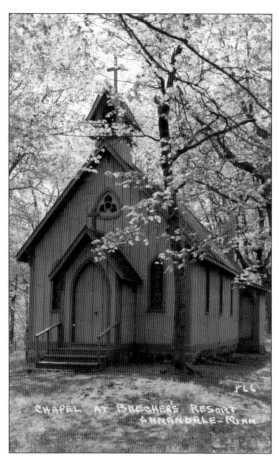

St. Mark's Episcopal Church still stands on land donated by Octavius Longworth. Rev. David Knickerbacker of New York, who had attended St. Mark's in New York with the Longworths, helped found the church. Small but substantially built, it is listed in the National Register of Historic Places. The famous Minnesota clergyman Bishop Henry Whipple dedicated the church in 1871, and it is still used on occasion.

As early as 1860, Clearwater had a school. It was taught by A.C. Powers, and the building was little more than a log cabin. The first two-story building erected in the county, the Clearwater Public School, was built in 1871 on Bluff Street next to the Congregational church. In 1906, the town voted for a high school to be added, so the building was expanded to include more classrooms.

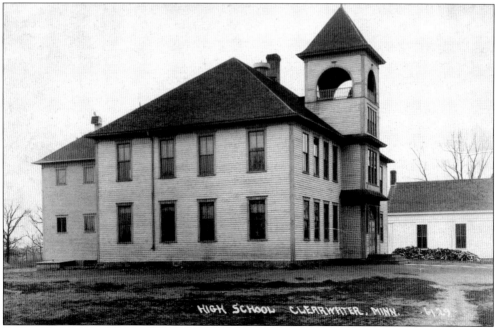

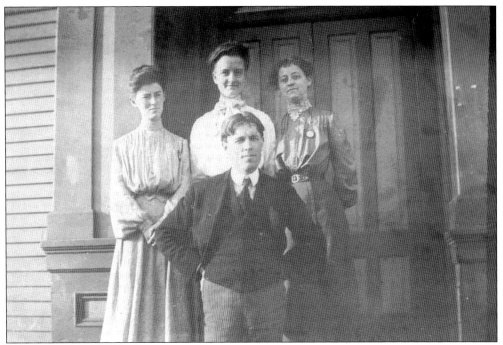

Clearwater Public School and High School supported a number of instructors. The four standing on the front steps could be any of the following teachers who taught from 1905 to 1913: E.F. Hamilton, Myrtle Bacon, Marjorie Macdonald, Grace Whiting, Jeannette Sandborn, and Howard Stewart. The high school graduated its last class in 1932, and its final classes of first through sixth grades attended until 1968, when the school joined with the St. Cloud school system.

Catherine Stevens graduated from the high school. Later, she taught here as well. The daughter of Charles and Sarah Bateman Stevens, she was born in Ohio in 1889. Charles was the son of Clearwater founder Simon Stevens. He was a minister and teacher. In the 1920 federal census, Charles and Catherine are listed as high school teachers. Catherine married William Lyons in 1925.

Abbie Freed was born Abbie A. Lease in St. Cloud. She earned her high school diploma and attended two years of college. A gentle woman, she taught in the rural schools, according to the 1920 federal census records. When she was hired as the first- and second-grade teacher, she taught students how to read from the series of early readers featuring Alice and Jerry with their dog, Jip.

This picture of the seventh and eighth grades of Clearwater District No. 884 is typical, in that every year each class and teacher lined up on the front steps of the schoolhouse to have its picture taken. Instructor and principal Betty Monk arrived in 1956. This picture was taken in 1957. (Courtesy of Elaine Paumen.)

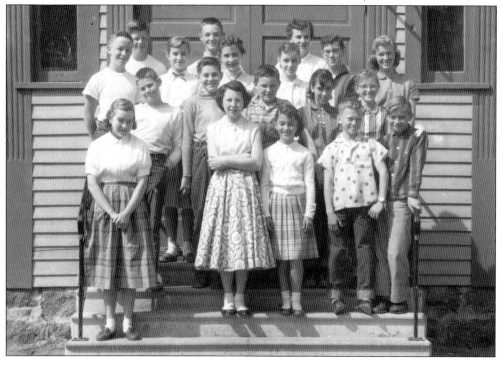

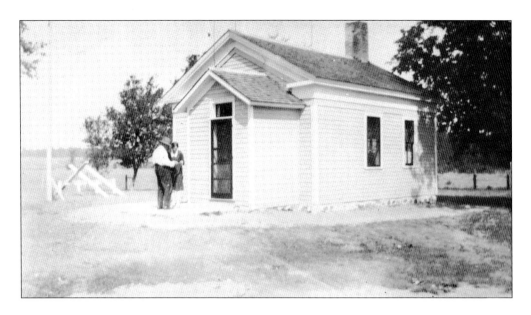

When the federal government granted lands to the public, it stated that every township had to set aside one section for the purpose of education. The Lee and McClellan Schools were such examples. Above, the Lee School in Clearwater Township was stationed on Highway 24. It is still standing, but the township moved it off the property. At one time, the Methodist Episcopal Church leader James Lee taught Methodist classes there as well. Below, the McClellan School was located close to the Sheldon farm on County Road 7 and 145th Street NE. In the picture below, Joyce Sheldon is standing in the back row at right. The dates noted on the back are 1935–1936. (Below, courtesy of the Sheldon-Tesmer families.)

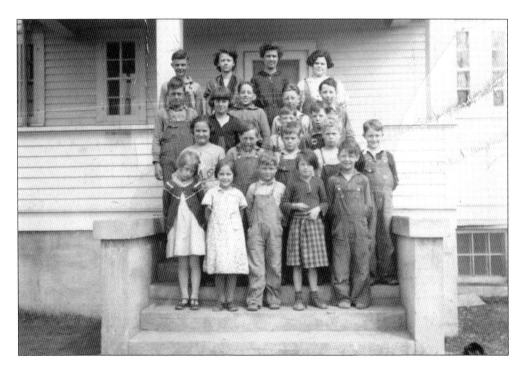

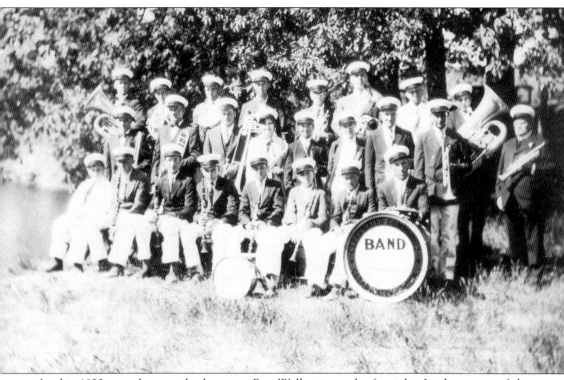

In this 1930s-era photograph, drummer Roy Walker is on the far right. In the center of the second row, the only female, Maxine Maxam, holds her alto saxophone. On the left, Maxam's future husband, Alfred Abeln, holds the trombone. In the back row, Fr. Joseph Kern is on the far right, fourth from the right is K.C. Miller, and fifth from the right, A.J. Maxam, father of Maxine, poses with his trumpet.

Seven

MURKY WATERS

Clearwater's attempts to become successful often took it into uncharted territory. In 1858, town founders rejected the Burbank Stage Company's offer to build a road from the river to Cold Spring, fearing forfeiture of fertile land. This decision lost the village a lucrative payback when St. Cloud accepted the offer.

By 1856, the community experienced its first violent act of nature, a flood destroying the first sawmill. Another flood on July 13, 1897, destroyed the Waite dam and both railroad and wagon bridges. In addition, Pat Quinn's saloon was swept away, along with many of the Church of St. Luke's records.

Fires caused problems too, burning the Masonic temple, the Catholic church, and Scott's Hotel. One leveled five buildings in 1891, and in 1895, another changed the location of the main businesses west of the ferry landing when it spread from the post office to Schneider's harness shop and Whiting's office building. Grasshoppers and drought plagued Clearwater too. Some settlers fled and never returned.

Many men enlisted in the Civil War, leaving Minnesota vulnerable during the Dakota Conflict. State volunteers assembled, building stockades and warding off attacks. Finally, President Lincoln created the Department of the Northwest to defeat the Sioux, a controversy that remains to this day.

Clearwater may have been a haven, but it was not immune to violence. Although Pat Quinn maintained a quiet saloon, he had to settle a few brawls. The village also experienced a number of burglaries. Burglars entered Phillips Drug Store and by the light of matches took drugs, a little cash, and cigars.

More shocking were the murders. In 1875, during a quarrel between brothers Nathan and Orrin Laughton, Nathan's gun discharged, killing Orrin. Nathan committed suicide in the state prison. Another murder took place in 1878, when Jane Townsend from Corinna Township picked up two axes, swinging at farm laborer William Dunham after he told her husband the two were having an affair. At her trial, Jane was found guilty, but she was also proven to be insane.

One of the most tragic situations happened in 1893. After being sent to lead the cows home, 16-year-old Alice Leonard, an Irish orphan living in Lynden Township, was found on the road, bludgeoned to death. Despite an inquest, reward for information about the murder, a stern reprimand from Judge D.B. Searle, and a number of suspects tongue-lashed in area newspapers, the crime went unsolved.

Like the rivers that flow near the village banks, Clearwater had its murky side. It was never predestined to become a metropolis, but its hardiness and determination helped keep the community flowing forward.

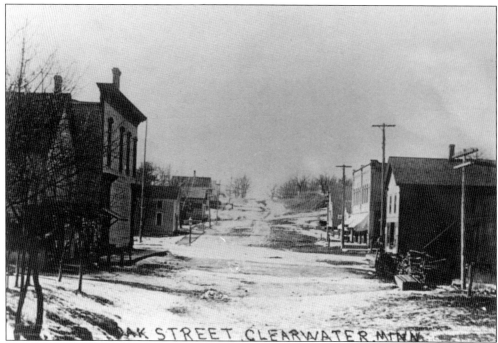

At one time, jewelry shops and hardware, dry goods, drug, and shoe stores lined Oak Street. An 1891 fire took out five buildings, according to the *Clearwater News* editor in 1892, who also condemned the village for not having a better pump and tank system, especially since the town was surrounded by water. In 1895, fire burned buildings on the left side of the street, including the post office. Pat Quinn's Saloon was swept away in the 1897 flood, along with the wagon and railroad bridges. Quinn relocated behind the Whiting Building on the left. Farther up the hill from the Masonic hall were the Morrison House and other businesses, but they, too, were lost to fire. The image below shows a busy village with wagons in front of the Masonic building. It still stands, while the other buildings have been lost, including the Whiting Building.

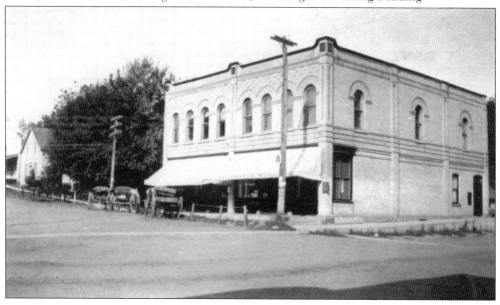

Alice Leonard, an orphan who lived with her grandmother Ellen Hayes in Irish Town, Lynden Township, was raped and murdered in May 1893. Many people were accused, and some were even maligned in area newspapers, but no one was charged with the crime. She is buried in St. Luke's Catholic cemetery.

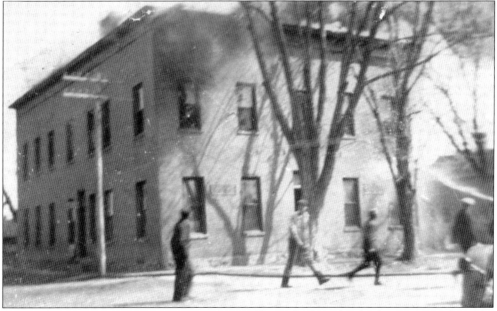

In 1924, a fire destroyed the Scott Hotel. This building, which used to be the Leme Hotel and the Clearwater Hotel before it was sold to Frank Scott, served the community for over two decades. The man with his foot raised is Herman Kloeppner, and the man on the left is Orin Oatman. (Courtesy of Elaine Paumen.)

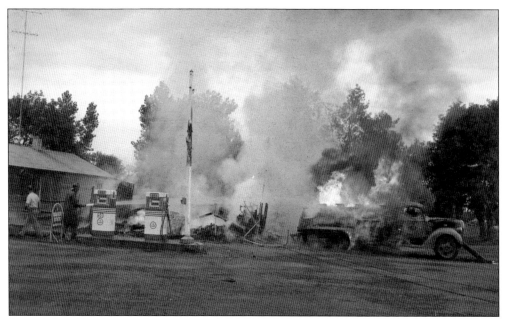

One of the village's worst disasters happened on August 12, 1954, at nearly 9:00 a.m., when an explosion at Leonard Killeen's gas station on Highway 152 killed his son Kenneth, Jim Nielson, who was having a tire fixed, and Jim Avery, who had stopped in to visit. The gasoline truck blew up at the same time. (Courtesy of Elaine Paumen.)

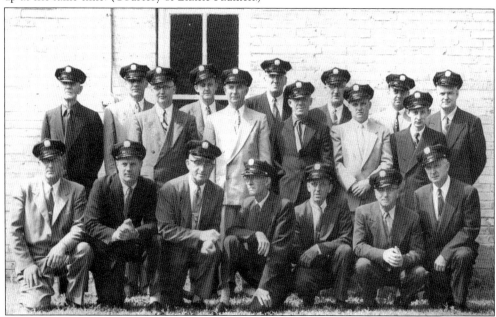

In solidarity, the fire crew attended the funerals of those who died in the Killeen explosion in August 1954. Here at the funeral of Kenneth Killeen are, from top left to bottom right, Hap Stewart, Oscar Strommer, Adolph Niebolte, Herman Kloeppner, Charles Benson, Edward Helget, Gerald Dickson, K.C. Miller, Orin Oatman, Cliff Auwarter, Jack Trovall, Robert Ferguson, Chris Hansen, Joe Jansky, Joe Wagner, Wes Schnorr, Arnold Helget, Ellis Kniss, and Martin Gallagher. (Courtesy of Elaine Paumen.)

Eight

DROPLINES

An editorial written in 1888 for the *Monticello Times* entitled "They Are All One—Marriage Has Made Everybody in Clearwater a Member of the Same Family" illustrates the relationships of many families around Clearwater. The author links the Draper family to Mitchells, Sheldons, Laughtons, Newells, Rices, Bentleys, Hyatts, Phillipses, and more. This interconnectedness kept community at the heart of all of Clearwater's endeavors for years. However, time changes everything.

The 1892 article "Is Clearwater Dead?" addresses this question overheard by the *Clearwater News* editor. Indeed, logging was played out, with fewer steamboats paddling the rivers. But James Hill's Great Northern connected the community to other parts of the country. With its elevators and flour mills, Clearwater was part of the great hub of industrialization and agriculture.

Yet, with the advent of the automobile, the circle of people's lives became larger, with more purchasing possibilities in bigger towns. Businesses began to close, with the Depression hammering nearly the last nail of growth. John Evans wrote his last column for the *Clearwater Herald* in 1930s. Banks closed. Phillips Drug Store sold out to Kniss Grocery before druggist Jennie Phillips died in 1940. Mercantile and variety stores changed hands a number of times before closing for good. A number of old families moved on or died off.

Nevertheless, the village did not fade away, it just moved from the river to the top of the hill. The Hollywood Motel and Steak House, owned by Larry and Joan Krenz, sat by Highway 152, now 75. It housed and fed overnight guests as well as construction and Northern States Power crews working on the nuclear plant in Monticello and employees working at T.O. Plastic Plant, managed by Robert Beech.

When the public school joined with Clear Lake and the railroad pulled out, Clearwater could have faded away like many towns if it had not been for the completion of Interstate 94 in the 1970s. Soon, restaurants and other businesses saddled up to the ever-busy roadway.

Leonardo da Vinci once said, "When you put your hand in a flowing stream, you touch the last that has gone before and the first of what is still to come." So, in answer to the 1892 article about Clearwater's death, the writer answered, and Clearwater echoes, "it's the liveliest corpse we have ever seen," with a melding of the old and new citizens and a population now over 1,700. From Old Home Week to Old Settlers' Picnics and now to Clearwater Heritage Days, the village continues to celebrate its remarkable past.

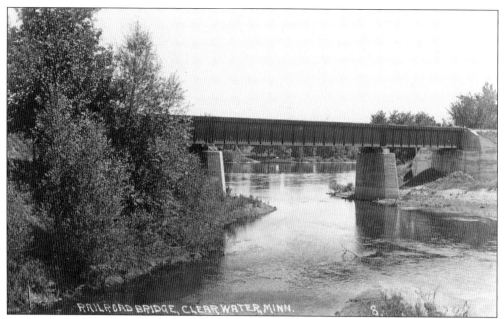

RAILROAD BRIDGE, CLEARWATER, MINN.

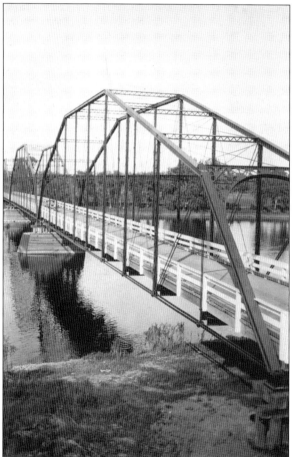

After the 1897 flood that washed away the railroad and wagon bridges, as well as Quinn's Saloon, the Great Northern built a stronger bridge to span the hills separated by Clearwater River flowing into the Mississippi. This bridge stayed put until the railroad pulled out of town for the last time in the 1980s.

Finally, after 75 years of ferrying that started with Simon Stevens, the village bought a bridge from Anoka in 1930. It was dismantled there and reconstructed in Clearwater to span the Mississippi. This connected Clearwater to Clear Lake, three miles away. Unfortunately, in the 1940s, floodwaters and ice took out this bridge, leaving Clearwater without a bridge and back relying on the ferry again.

This mid-1930s picture may have been taken at the Old Settlers' Picnic, celebrated each summer. Many here are children of early settlers. Pictured, from left to right, are (back row) Jennie Phillips, Alice Pineo, unidentified man and woman, Jeanette Sanborn Whittemore, and her husband, Charles Whittemore; (front row) unidentified, Elizabeth Collins, Catherine Stevens Lyons, and unidentified.

Charles Whittemore and his male friend are having a good time being dressed up in women's accessories, shawls, hats, and gloves. Charles Whittemore's second wife, Jeannette Sanborn Whittemore, is tying his bonnet. Jeannette married later in life and in the 1960s appreciated the Methodist Youth Fellowship's help raking her leaves and washing her windows. She lived on Main Street in the home of her aunt and uncle, Dexter and Elizabeth Collins, which had a dirt kitchen floor.

Long past its milling history, the Clearwater River was dammed up close to the mouth of the Mississippi between 1936 and 1939. The bridge over the Clearwater was part of the beautiful, winding, but occasionally dangerous Highway 152. More stable and now permanent, the river makes its final flush on its way from Meeker County to Wright County.

This picture is dated sometime in the 1940s and was taken at the north end of Maple Street, below the school hill and kitty-corner from St. Luke's. This is obviously either the Fourth of July or Memorial Day because of the swaying flag; the woman presenter looks as though she is swinging with patriotism and enthusiasm over her topic of discussion.

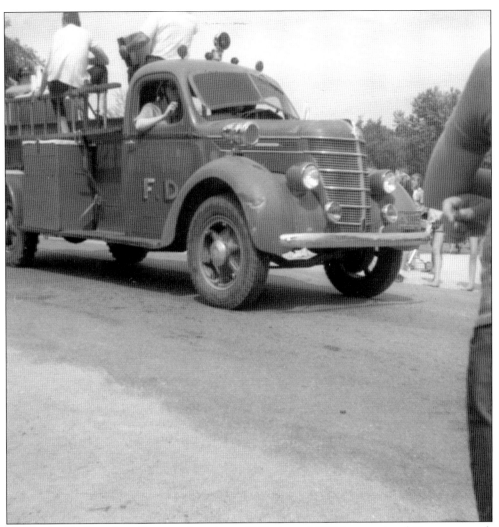

Although old when the village purchased it in 1953, the red 1937 International Harvester truck offered firemen the advantage of driving it out to rural areas because of a water pump on the back. Rural people and farmers signed contracts with the fire department in order to receive service if and when they had a fire. The first trip was to Lyle Heaton's to extinguish rubbish flames. (Courtesy of Elaine Paumen.)

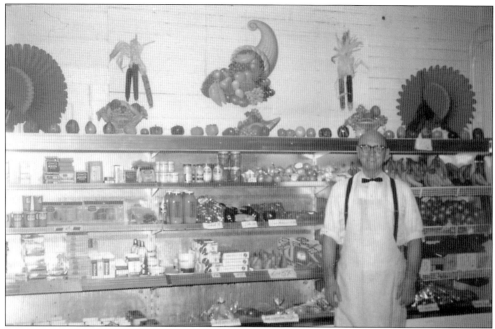

Born in Clearwater in 1902, Ellis Kniss bought Jennie Phillips's drugstore around 1940. He and his wife, Rachel Eldridge, a teacher born in Wisconsin, ran Kniss Grocery. On Halloween, they treated youngsters to full-size Hershey bars. Rachel died in 1950. Ellis married twice more, first to Deloris Evans and then to Lydia Weigand, a teacher in Clearwater. He had the distinction of being the most asked-for pallbearer. (Courtesy of Ken Abeln.)

In many communities, 4-H participants learn strong values when they enroll in the program. The Lynden-Go-Getters started their branch in 1951. Organized by the Flynns, Ergens, and Murphys, the club started with 12 members. Those pictured here in the back are leader Flora Miller (far left) and treasurer Sally Flynn (second from left). On the right is leader Joe Feldges. Also pictured are vice president Dick Powell and reporter Marie Miller.

These charter members of the Lynden Township Homemakers Extension group gathered in 1947 to honor Anna Abeln's 25 years of service. She was presented with a cake and corsage and a "This is Your Life" presentation. Most of these women are descendants of the early settlers. Pictured are, from left to right, (standing) Catherine Lyons, Stella Hinz, Ann Stokes, Mable Stokes, and Jane Ostrander; (seated) Josephine Barrett, Anna Abeln, Nell Murphy, and Mrs. ? Mann.

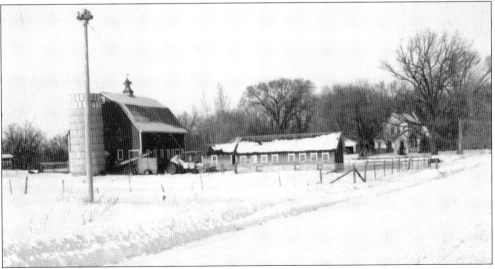

Pictured here is the Levi Sheldon farm located in Clearwater Township. The house is on one side of the road and the barn and other outbuildings are on the other. Levi was the son of George and Mary Ann Wells Sheldon. He married Ebba Pearson. The couple had two children—a daughter, Joyce, who married Carl Tesmer, and a son, Howard. (Courtesy of the Sheldon-Tesmer families.)

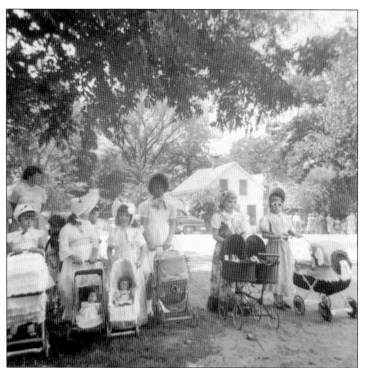

The 1955 Clearwater Centennial was celebrated with a big picnic and parade. This photograph, taken near the Clearwater Creamery, where the parade started, shows girls dressed in old-time costumes waiting to push their baby carriages down Main Street. The first three from the left are Helen Hansen, Cindy Frank, and Carol Allen.

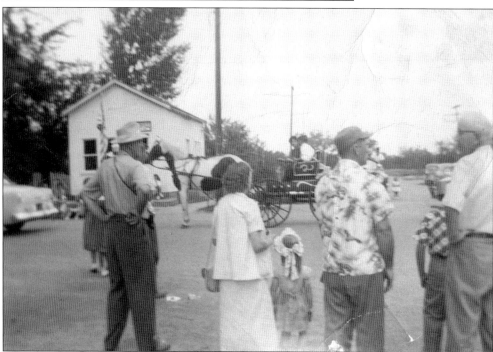

This photograph of the 1955 Clearwater Centennial shows the center of the village. Guests watch the parade as each exhibit passes in front of Kniss Grocery, formerly Phillips Drug Store. Kitty-corner behind the horse is the post office, which used to be Lyon's Groceries. The train depot would be farther back on the right.

Card parties, especially playing 500, often brought a gathering to homes and the St. Luke's church basement. In this 1955 New Year's Eve photograph taken at the Frank home at Warner Lake in Lynden Township, (clockwise from left) Harold Frank, Olga and Herman Gohman, and Joe Feldges are a foursome. This date was always a double celebration for Harold and Winifred Frank, because they were married on New Year's Day 1944.

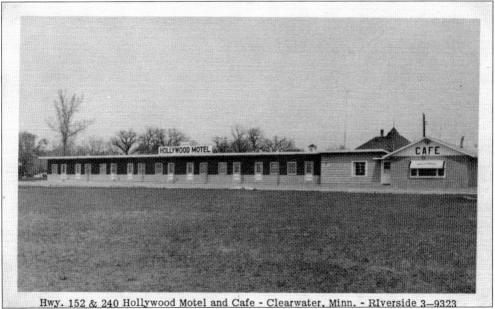

Hwy. 152 & 240 Hollywood Motel and Cafe - Clearwater, Minn. - RIverside 3—9323

The Hollywood Motel and Steak House was originally built in 1957 by Ray Mathees, who hired Barney Fish to do the cooking. In 1958, Larry and Joan Krenz bought the business, running it until 1975. It was moved from its location on Highway 152 closer to Interstate 94. They operated the business two more years at this location. Larry and Joan were known for their steaks, steak sandwiches, and Sunday dinners.

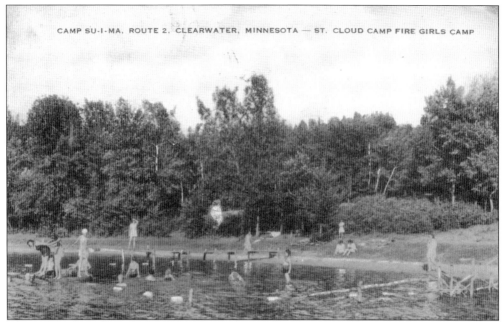

Located on the southeast side of Warner Lake, Camp Suima opened every summer for Camp Fire Girls. Alice Wheelock Whitney organized and supported the first camp in the late 1930s. Every night, when weather cooperated, the girls built a bonfire and sang camp songs like "Kumbaya." A number of Clearwater girls participated in the camp.

Winifred Frank rented Dick's Lunch in the early 1960s from Clifford Powell. Off old Highway 152, connecting St. Cloud to Minneapolis and all points north and south, this diner served affordable, full-meal lunches for the workers in the community. The menu included roast beef, pork chops, and creamy mashed potatoes and gravy, breakfast, supper, ice-cream cones, chocolate malts, coffee, and Coca-Cola.

K.C. Miller (right), his wife, Eleanor, and their family lived on Main Street in the former Dr. Kingsbury home. Miller is pictured here with Bob Beech. The Beech family—Bob, Lois, and their three children—moved into the village in 1956. For a few years, the family lived in the Fred Murray house. They were known for their love of horses.

Bob Beech started the T.O. Plastics Plant in Clearwater. Searching for business opportunities for the village, the town council realized what this business could offer the community. Once opened in the downstairs of the Masonic hall, T.O. Plastics gave the village the economic boost it needed. Relocated to the top of the hill and expanded many times, it still stands at the crossroads of Minnesota 24 and County Road 75.

The Pond
6.34, Clearwater Minn.

Ruth Sheldon writes adoringly about the millpond in her narrative about Clearwater. Although its shape changed a few times, people's thoughts about this charming watering hole did not. Here, kids learned to swim with the help of a Red Cross–endorsed teacher. On the grassy south bank, beginners learned in the shallow waters. On the sandy north side, because of the depth and diving boards, more advanced swimmers learned.

Emma Otten was born in 1893 in Sweden and came to America when she was 18. Her husband was a time and lock expert for banks, according to the 1930 federal census. A well-respected woman, Emma had the distinction of being the first female mayor of the town, from 1952 to 1955, and supervisor of the 1955 Clearwater Centennial. Helen Dickson was the next woman mayor, in the early 1960s.

All these items of memorabilia depict an active community. From the butter dish to the syrup pitcher, these treasures were for sale or were promotional giveaways at local businesses such as Wallace Webster's Corner Store. The button celebrates Clearwater's centennial in 1955. The notebook/calendar was probably handed out by Whittemore's Insurance Company. The oval tea-bag dish labeled Hollywood Motel and Steak House was sold when the restaurant and motel went out of business.

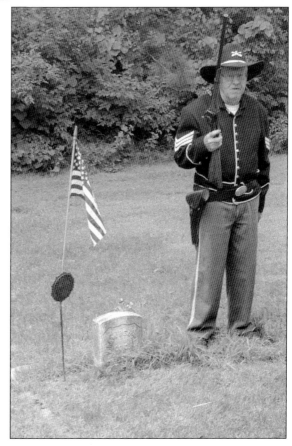

Wearing a Civil War uniform, George Bentley is pictured here during the 2015 Clearwater Heritage Days Celebration. He is standing by his great-great-grandfather's grave at Acacia Cemetery. Hiram Bentley fought in Company C, 7th Michigan Cavalry. His wife, Anna Merrill Bentley, is buried next to him. George has many ancestors who were settlers in Clearwater and are buried in this cemetery.

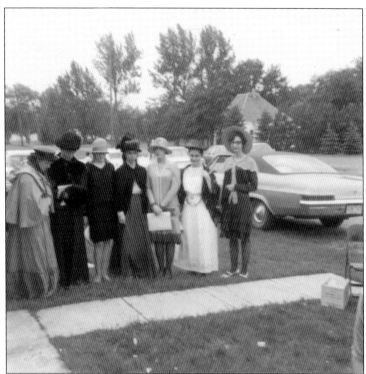

This group of young women dressed up in old-time costumes represents various eras from Clearwater's settlement in the 1850s on up to the 1930s. Mildred Nordell introduced the women at the Old Settlers' Picnic in 1970. From left to right are Carol Pribyl, Judy Helgeson, Wanda Gramsey, Laurie Burnett, Cindy Frank, Kitty Helget, and Elaine Paumen. The group, many from the Clearwater United Methodist choir, also sang songs representing various time periods.

David Agnew, a descendent of early settlers David and Mary Jane Stevenson Agnew, helped the community celebrate at the 2015 Clearwater Heritage Days by participating in a rendezvous down by the Clearwater dam in Lower Park. The group did a believable reenactment, with the heady smell of campfire smoke in the air.

Jessie Maud Porter made Clearwater proud. She was one of the first born in the village, to Thomas and Abigail Robinson Camp Porter in 1862. From childhood on, she saw the community stretch and grow and then start to shrink again. A long-standing Methodist, Maud was a charter member in the Rebekah Lodge and Eastern Star. In addition, she was a member of the Woman's Christian Temperance Union and preached the suffragette message. A milliner, Maud lived her entire life in Clearwater. After her parents died, she sold their farm and moved to Main Street. When she was 102, she, a Republican, was asked to dedicate the new Mississippi bridge. After a ride in the Democratic governor Orville Freeman's car, she said that the governor was so nice she could have turned Democrat. Maud Porter lived the life of which stories are written and died when 103. (Courtesy of Kitty Johansen.)

DISCOVER THOUSANDS OF LOCAL HISTORY BOOKS FEATURING MILLIONS OF VINTAGE IMAGES

Arcadia Publishing, the leading local history publisher in the United States, is committed to making history accessible and meaningful through publishing books that celebrate and preserve the heritage of America's people and places.

Find more books like this at
www.arcadiapublishing.com

Search for your hometown history, your old stomping grounds, and even your favorite sports team.